FEDERICO ZERI (Rome, 1921-1998), eminent art historian and critic, was vice-president of the National Council for Cultural and Environmental Treasures from 1993. Member of the Académie des Beaux-Arts in Paris, he was decorated with the Legion of Honor by the French government. Author of numerous artistic and literary publications; among the most well-known: *Pittura e controriforma*, the Catalogue of Italian Painters in the Metropolitan Museum of New York and the Walters Gallery of Baltimora, and the book *Confesso che ho sbagliato*.

Work edited by FEDERICO ZERI

Text
based on the interviews between
FEDERICO ZERI and MARCO DOLCETTA

This edition is published for North America in 2000 by NDE Publishing*

Chief Editor of 2000 English Language Edition
ELENA MAZOUR (*NDE Publishing**)

English Translation
DIANA SEARS

Realization
ULTREYA, MILAN

Editing
LAURA CHIARA COLOMBO, ULTREYA, MILAN

Desktop Publishing
ELISA GHIOTTO

ISBN 1-55321-018-2

Illustration references

Alinari Archives: 26b, 45/II.

Bridgeman/Alinari Archives: 28b, 30a, 39, 41b, 42ad, 43a-b, 45/IV-VIII.

Giraudon/Alinari Archives: 17a, 18-19, 21, 23a, 27, 32, 36b, 37, 38, 41a, 44/III-VIII-IX, 45/III-XIII.

Luisa Ricciarini Agency: 35.

RCS Libri Archives: 2, 4-5, 6b, 8bd, 9bd, 10b, 15b, 16a-b, 17b, 19a-b, 22-23, 23b, 24b, 25, 28a, 29, 30b, 30-31, 33, 34-35, 40, 42as-b, 44/I-II-V-VI-VII-IX-X, 45/I-V-VI-IX-XII-XIV.

R.D.: 24a, 26a, 36a, 40as-ad, 44/IV-XII, 45/X-XI.

Scala: 1, 2-3, 4, 6a, 6-7, 8s-ad, 9s-ad, 10a, 10-11, 12, 12-13, 14-15, 15a 20a-b, 45/VII.

Printed and bound by Poligrafici Calderara S.p.A., Bologna, Italy

* a registered business style of NDE Canada Corp.
15-30 Wertheim Court, Richmond Hill, Ontario
L4B 1B9 Canada, tel. (905) 731-1288

The captions of the paintings contained in this volume include, beyond just the title of the work, the dating and location. In the cases where this data is missing, we are dealing with works of uncertain dating, or whose current whereabouts are not known. The titles of the works of the artist to whom this volume is dedicated are in blue and those of other artists are in red.

WATTEAU

THE EMBARKMENT FOR CYTHERA

THE EMBARKMENT FOR CYTHERA is one of the great masterpieces of Jean-Antoine Watteau, who gained fame as the painter of *fêtes galantes* (scenes of gallantry). In this painting he infuses that particular atmosphere

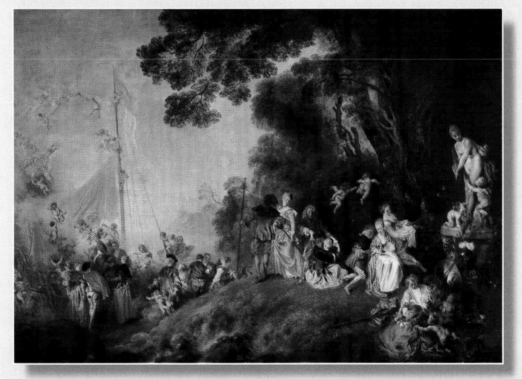

characteristic of the aristocratic life of the *ancien régime*, which Talleyrand called the "sweetness of living." Light, transparent colors are spread with a rapid, luminous brushstroke that unites all the elements of the story in a fluid composition.

AN ARISTOCRAT OF PAINTING

THE EMBARKMENT FOR CYTHERA

1718-19

● Berlin, Charlottenburg Castle (oil on canvas, 129x194 cm)

● The picture, today in Berlin, is the second version of a subject already treated by Watteau in a painting with a very similar composition and an identical title, now in the Louvre.

● The first work dedicated to the subject was done in 1705 (*The Embarkment for Cythera*, now in the Heugel Collection in Paris): it is considered an illustration of Dancourt's play, *Les trois Cousines*, represented for the first time on October 18, 1700. The railing and gondola that appear in the painting, however, bring to mind also the comedy-ballet *La Vénitienne*, set to music by de La Barre with the words by de La Motte and performed for the first time in 1705.

● *The Embarkment for Cythera* manifests one of Watteau's great passions: the exaltation of love as a cultural expression of "civilized" man. It is a feeling seen through the filter of Enlightenment thought, which does not separate reason and the heart, but considers them intimately fused.

● Other themes central to the painter's poetics are the theater, scenes of gallantry, and the celebration of painting itself, evident in his last masterpiece, *L'enseigne de Gersaint* (*Gersaint's Sign*).

● Moreover, Watteau's works show a profound bond with one of the most significant forms of eighteenth century literary expression: *conversation*, considered a social catalyst. In his paintings one finds a sort of illustrated translation of this art.

◆ A STUDENT
OF HIS TIMES
Jean-Antoine Watteau
(Valenciennes, 1684 -
Paris, 1721),
was trained in Paris
where he studied
the world of theater.
His meeting with
the collector Pierre
Crozat introduced him
to the works of Rubens,
Rembrandt, Van Dyck,
allowing him to move
beyond an academic
approach to painting.
The accord between
characters and
landscape in his
paintings derives
from Venetian
tradition.

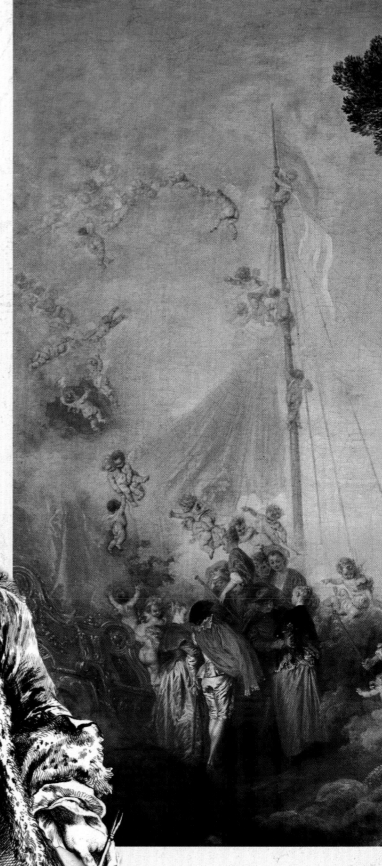

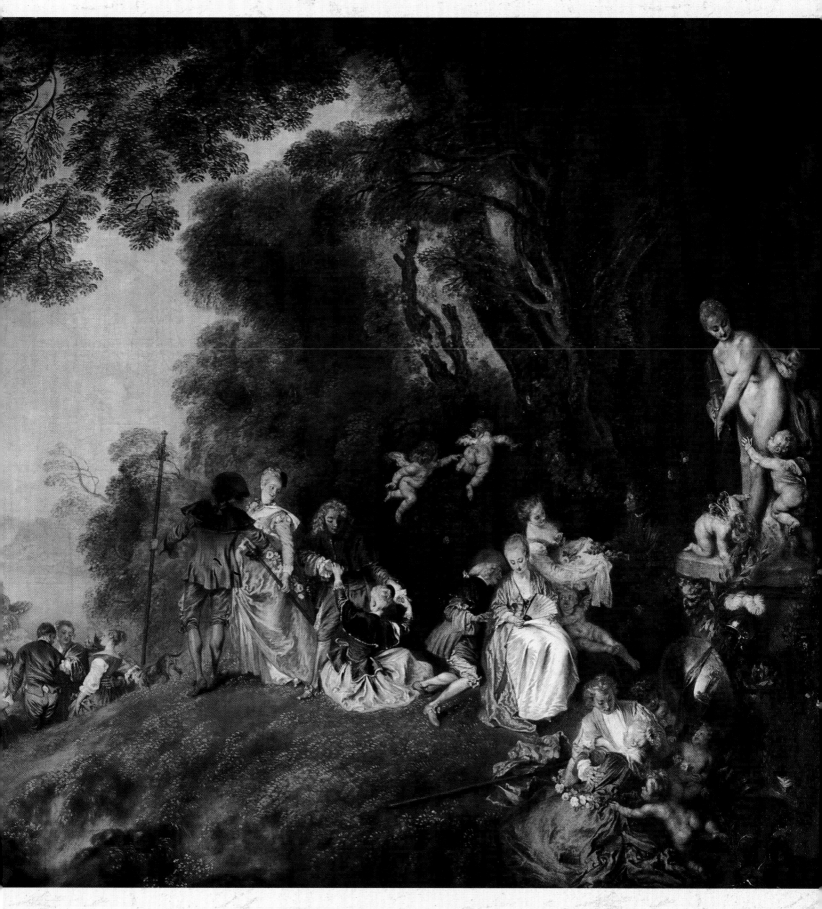

THE CELEBRATION OF LOVE AND THE SWEETNESS OF LIVING

Cythera is an island in the Aegean Sea that was in classical antiquity dedicated to the cult of Venus. *The Embarkment for Cythera* is thus an exaltation of love and the sweetness of living (*douceur de vivre*).

● The subject of the painting was elaborated by Watteau during his second sojourn in Paris. The painter had presented some paintings to the *Académie Royale* hoping to obtain a grant to stay at the Villa Medici in Rome. But the academicians welcomed his works with such favor that, instead of sending him to Italy, they received him into the Academy itself.

● His reception entailed the presentation of a work on any subject. *The Embarkment for Cythera* was in 1717 immediately re-

◆ A FESTIVE PROCESSION
The Berlin painting, below, shows couples in varied and graceful poses as they move in slow procession toward the embarkment. The circle of cupids around the mast of the boat repeats the rhythm defined by the curve of the figures. This harmony of line, compared with

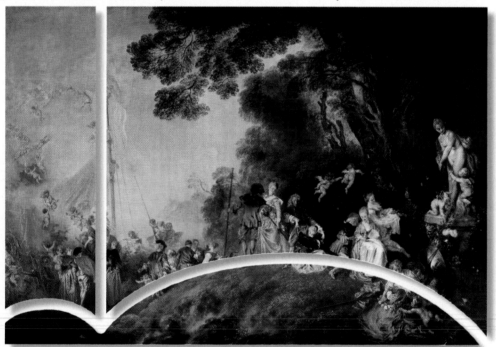

ferred to as a *fête galante*, a definition that afterwards remained tied to the painter.

● The painting was an enormous success, eclipsed only during the Revolution, when it was taken off the wall at the Louvre and fell into temporary oblivion. But in 1748 Caylus had already criticized it for lack of "action."

● Between 1718 and 1719 Watteau painted another canvas with the same subject, now in Berlin in the Charlottenburg Castle. The compositional structure of both paintings is based on a curving line that departs from the bottom right corner, rises toward the center, and then descends to the left where the preparation for the embarkation is represented.

the Paris version, seems to produce the curve of the statue on the right, as though seconding the movement of the branches. The choice of more blaring tones, although in perfect harmony with the colors of the background landscape, gives greater vivacity to the fantastic vision.

◆ THE ISLAND: A VISION
In the version of the painting in the Louvre, painted in 1717 for the *Académie Royale de Peinture* of Paris, the landscape plays a crucial role. The composition modulates the presence of the figures in space, emphasizing the naturalistic elements. Ample space is left for the view of the island in the distance. The brushstrokes leave undefined the contours of the trees, the plants, the ground, and everything seems enveloped in a cloudy, dreamlike atmosphere. A sense of incompleteness dominates, suspended between reality and fantasy. Embarkment for the island of love is thus veined with a lyrical tone, evocative and sentimental. But the protagonists of this fairy tale, the various couples in love, are wearing fashionable clothes: Watteau projects thus a scene of contemporary life in an atemporal dimension.

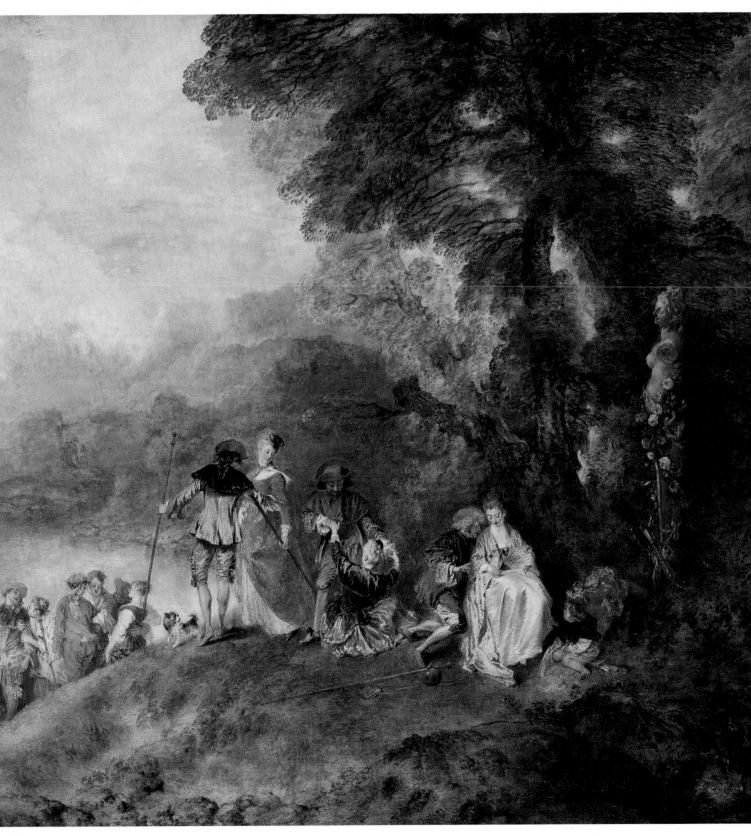

ANALYSIS OF THE WORK: SIGNIFICANT VARIATIONS
COMPARISON OF TWO PAINTINGS

The Charlottenburg painting is different from the one in the Louvre in its numerous variations of composition and technique. First of all, here there are more couples, with a total of 24 characters, whereas there are only 18 in the Paris version. Two of the additional figures fill the area below the statue of Venus in the right corner, empty in the preceding version. But the most conspicuous addition is perhaps the mast of the boat with the cupids climbing up it. Those already seen flying around in the 1717 painting are here placed in a circle, to raise the sails.

● Everything works together to give the scene a light atmosphere, one of trepid and joyous but delicate waiting, as if veined with a light melancholy. It is in this key that one can read the painter's aspiration for *sweetness of living* that seems represented more like a faraway chimera than a truly accessible horizon.

● Yet, unlike the Paris painting, the Berlin *Embarkment* uses a more sharply defined pictorial language. This clearer vision seems to give greater concreteness to the dream, to the imaginary voyage toward the island of love.

● Watteau's friendship with art merchants and art lovers and important personages such as the collector Pierre Crozat, royal treasurer, and Claude III Audran, *conservateur* of the *Palais de Luxembourg*, permitted him to improve his artistic culture and to investigate themes related to his contemporary worlds of the theater and civil society.

● The painter received commissions for his works from his social sphere, which was pleasure-loving and refined. The second version of *The Embarkment for Cythera* was most probably painted for his friend the collector Jean de Jullienne, to whom it belonged in 1733 when the engraver Nicolas-Henri Tardieu prepared a print of the painting, indicating de Jullienne as its owner.

● Ten years later, in 1743, the painting appeared in The Hague at an auction as part of the collection of Jacob Lopez de Liz, a very rich Portuguese who had raised a scandal during his sojourn in Paris and had rapidly gone through his fortune. Around the middle of the eighteenth century the Watteau painting passed into the collection of Frederick the Great of Prussia, where it remained until 1983 when it was purchased by the German State.

◆ A HERM ENCIRCLED WITH ROSES
In the Louvre *Embarkment* branches of roses are entwined below the bust of the statue that seems to be watching over the courting and loving embraces of the various couples. Venus's closed eyes might allude to the sensual pleasure resulting from love; references to this might also be the symbols of Bacchus and Eros recognizable in the panther skin and the bow, quiver, and arrows entwined at the base of the herm.

◆ THE STATUE OF CUPID
The herm encircled with a garland of roses in the Paris painting is replaced by a statue of Venus and Cupid, as seen in Watteau's preceding work, *Young Couples near a Statue of Venus and Cupid* (1717, Dresden, Gemäldegalerie). The three cupids with Venus - one is part of the sculpture, the others are live characters - represent Eros, Anteros and Harmony. The play of their poses inserts the statuary group into the fantastic narration of the gallant Embarkment.

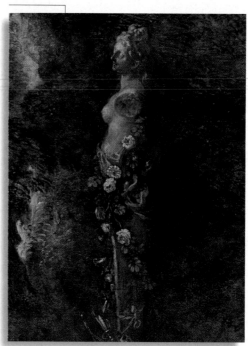

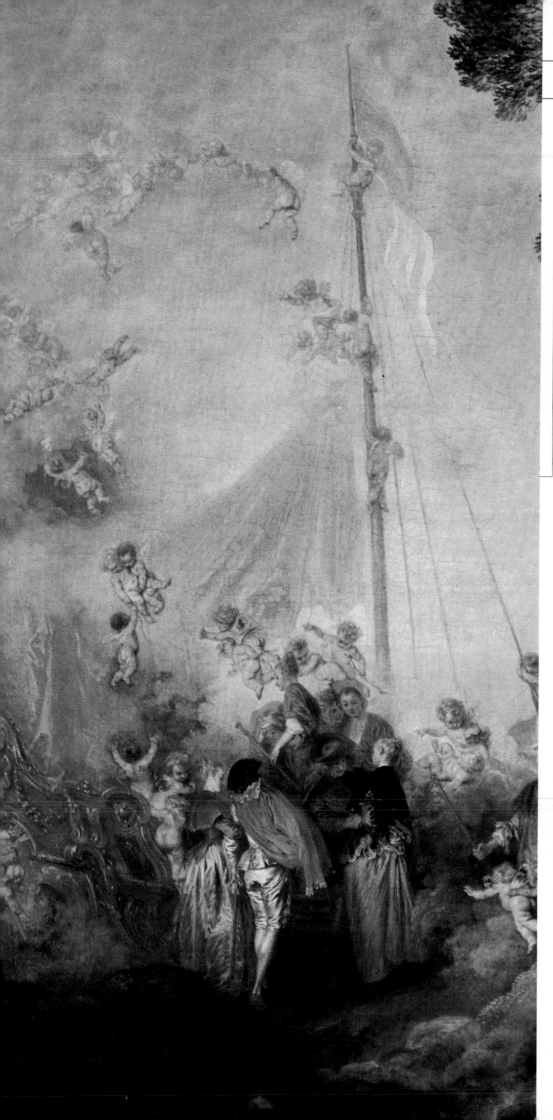

The Greek island
of Cythera glimpsed
in the background
of the Paris painting has
disappeared
in the Berlin version,
and the allusion
to the mystery of love is
indicated by the sphinx
figurehead on the boat.
The aura of
indefiniteness and
mystery that envelops
the voyage is further
reinforced by Watteau's
skillful rendering of
atmosphere in his
depiction of the sky,
from the haze that
becomes lost in
the sea, to the milky
light that confuses dawn
and dusk
creating a sense
of suspension.
The curve of the little
cupids flying in
the clouds partially
covers the sail, hiding
it from sight, thus
accentuating the sense
of mystery of the voyage.

In *The Embarkment for
Cythera* in the Louvre,
a suggestive landscape
appears in the distance,
enveloped in a fog
that accentuates
its arcane character.
The mountains
of the Island of Cythera
suggest faraway
dimensions, evoke
oneiric landscapes,
dream images that
could, perhaps, become
real. Having arrived for
embarkment, the first
couples prepare to
board the boat, and
here Watteau plays at
merging the different
temporal dimensions:
whereas the couples
wear eighteenth century
costumes, the two
boatmen have the look
of classical personages.
The allusion is perhaps
to the loss of normal
references to time
and space that
the voyage toward
the Island
of Love entails.

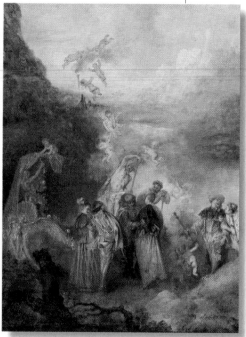

♦ AMOROUS
ALLUREMENTS
The couple constitutes
the fulcrum of
the composition.
With his right arm
the man encircles
the waist of the woman,
who, almost hesitating,
turns her head
backwards, perhaps
to see if the other
women have, like her,
ceded to the allure
of love.

♦ THE HEART
OF THE PAINTING
Watteau has placed
the couple forming
the cardinal point
of the composition
at the top of the grassy
hill being crossed by
the procession of lovers.
The man is dressed in
a red suit with a dark
cape, on which
the brighter red ribbon
binding his hair stands
out. The woman, who
wears a brown dress in
the Paris painting, here
has an elegant yellow
dress decorated with
a garland of roses.

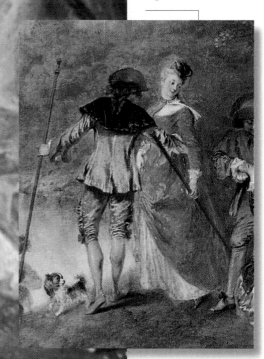

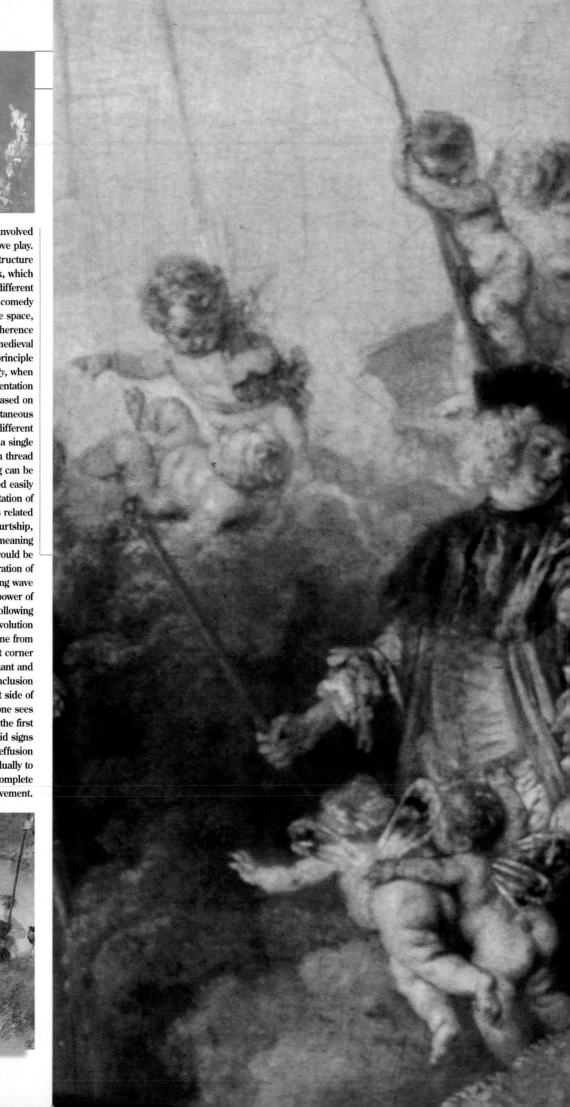

♦ COUPLES READY TO EMBARK

This is the area where the two versions of *The Embarkment for Cythera* present the greatest analogies. The number of the couples is in fact the same, and only a cupid has been added. What changes in the two paintings is the clothing. In the Louvre painting it is simpler, in the Charlottenburg one the costumes are richer and the brushwork defines them more distinctly. The subject of the *Pilgrimage to the Island of Cythera*, the title with which the work was registered at the *Académie* in Paris, has been interpreted as a metaphor for the paths and phases of love. The sequence of couples distributed throughout the composition synthesizes, in fact, the various stages of courtship, and in this sequence one can grasp the changing nuances of the feelings of the woman and the man involved in love play.

The very structure of the work, which shows the different "scenes" of the comedy of love in a single space, reveals an adherence to the medieval theatrical principle of *simultaneity*, when the representation was based on the simultaneous development of different episodes on a single stage. If the main thread of this staging can be evidenced easily in the presentation of different poses related to courtship, the final meaning of the work would be the celebration of the ascending wave triggered by the power of love. In fact, following the evolution of the scene from the bottom right corner to its triumphant and joyous conclusion on the left side of the painting, one sees clearly how the first timid signs of words and effusion lead gradually to increasingly complete amorous involvement.

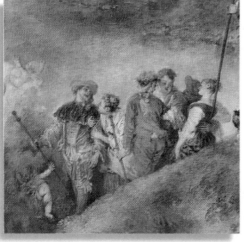

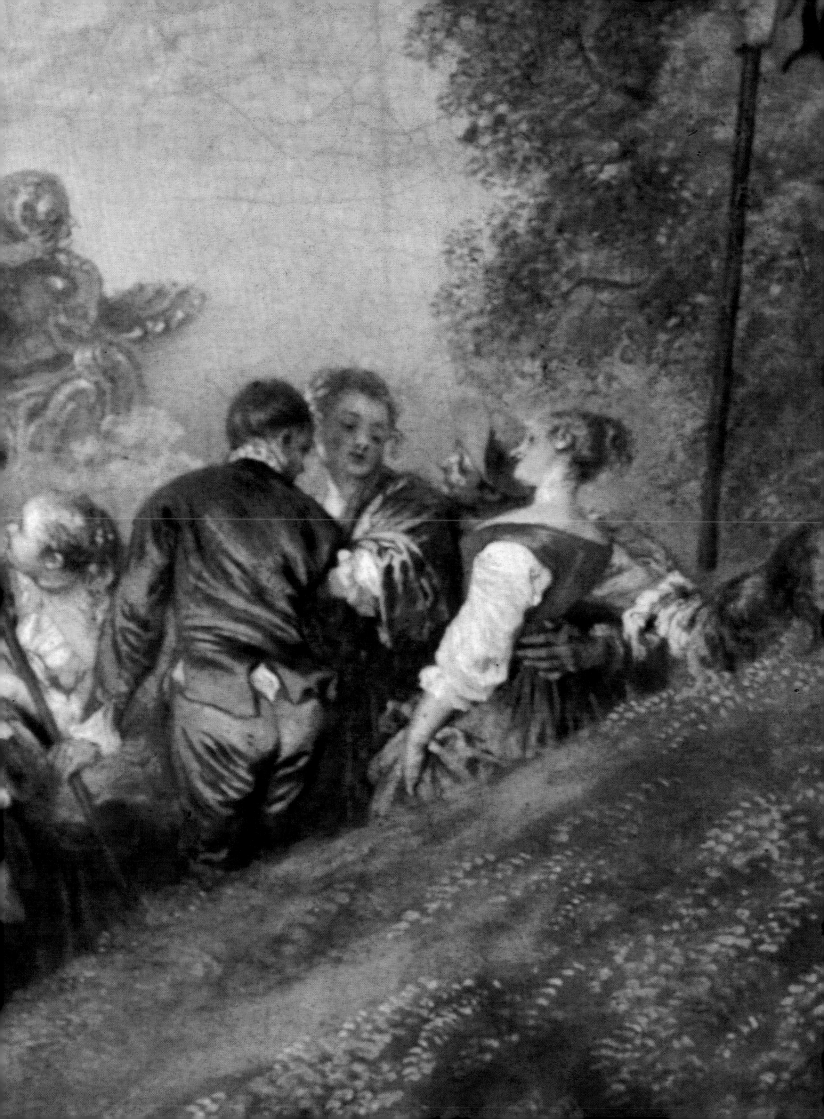

♦ A NEW COUPLE
This new couple, which according to some critics mars the compositional and narrative flow of the soft development of the story in the Paris painting, seems to be almost a symbolic summary image of the entire meaning of the work. The close association with the statue of Venus, enriched with the cupids, symbols of Eros, Anteros and Harmony, with Mars' weapons and Apollo's laurel at the base, emphasizes the couple's erotic significance. Lying softly on the grass, the two young lovers are united in a tenderly amorous pose, and their union is sealed by the garland of roses that the three industrious cupids are wrapping around them. This new couple could probably be read as an introductory icon and at the same time a summary of the work.

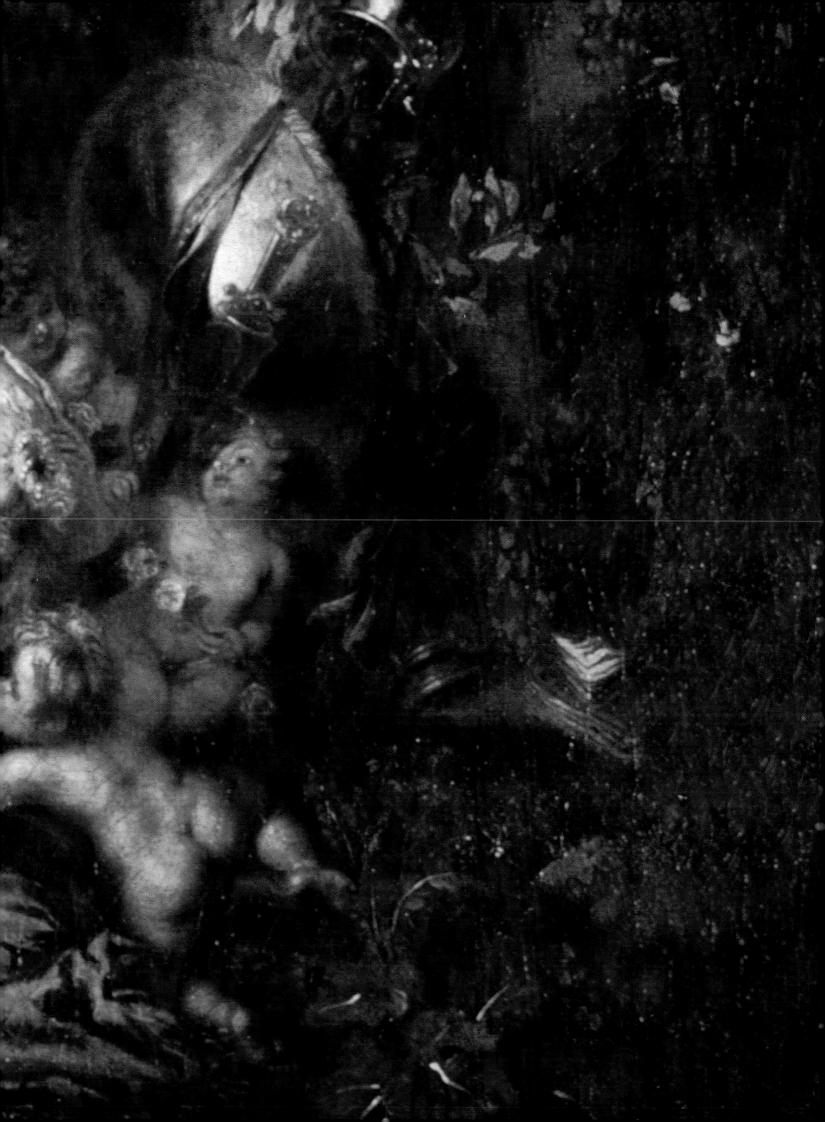

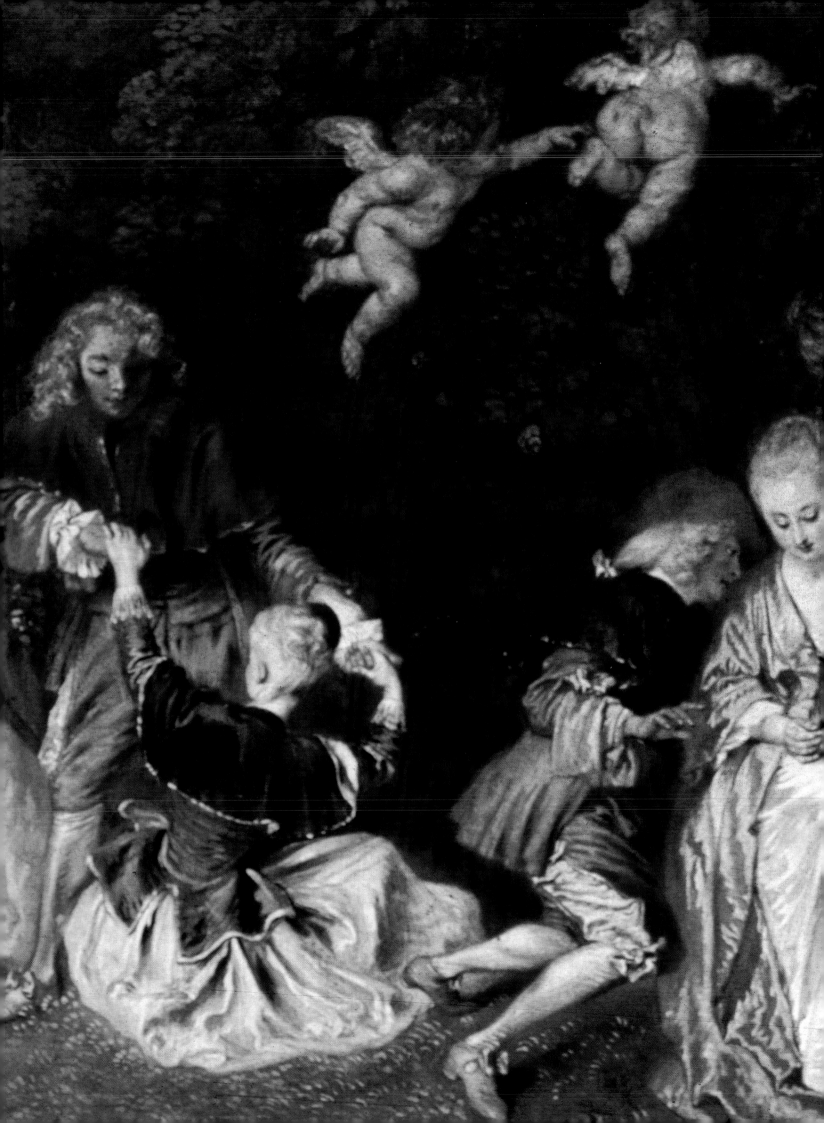

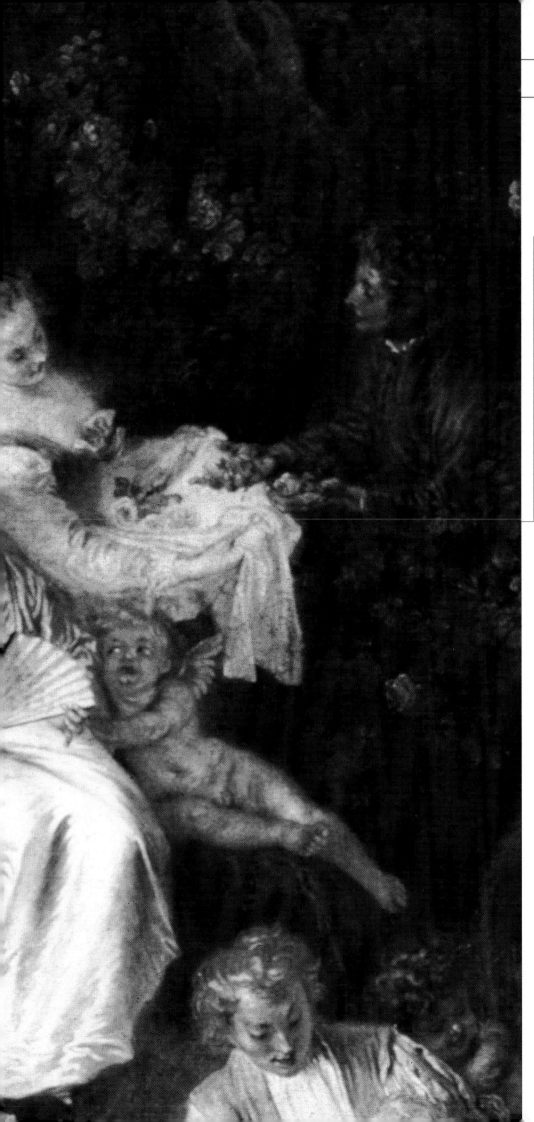

◆ LOVING DIALOGUES

Watteau has placed various couples in different poses in the central part of the picture. Starting at the left we see a young man helping his partner to get up; then a suitor who is trying with the subtle and seductive weapon of words to conquer a seated woman who appears still uncertain. Finally, behind them, a young couple is gathering roses in a white cloth. Above them all, two cupids fly around. In the Paris version the man on the left wears a hat that does not appear in the Berlin painting. Otherwise the two figures are very similar, except for the hair that, as in the other male figures, is fluffier and painted in light tones. There are greater differences between the two versions in the central couple. In the Louvre painting, where one continues to observe traces of a more indefinite brushstroke compared to the more decisive and brilliant touch of the Berlin one, the undecided woman is prodded by the small Eros crouched sitting on his quiver at her feet, as in a typically infantile gesture he pulls at her dress. The Eros in the Charlottenburg picture appears instead much more insistent as, half reclining behind the woman, he seems to be pushing her forcefully toward the kneeling suitor. This couple, which constitutes one of the crucial points of the work and with which the story begins in the Paris version, expresses a concept dear to Watteau's poetics and fundamental in eighteenth century culture: the value of words, of *conversation* as an instrument of knowledge and comunication in aristocratic society. The background for this couple is another couple with a young man offering flowers of love to his partner, who is gathering them in her skirt.

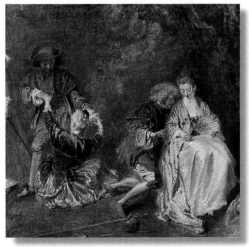

BETWEEN STREET THEATER AND *SCENES OF GALLANTRY*

Jean-Antoine Watteau was born in the town of Valenciennes, in the north of France on the border with Belgium, in October 1684. His life remains shrouded in mystery, as does much of his work, because the painter had the habit of neither signing nor dating his work. Little is known of his artistic formation and his personal life. We know that his studies took place in Valenciennes in the workshop of the local master Jacques-Albert Gérin (c. 1640-1702) who does not seem to have left deep traces in his art. In 1702, after the death of Gérin, the painter went to work with another artist who specialized in theater sets. Soon after, he moved to Paris where he studied Flemish and Dutch art with particular interest and began to do *genre* painting in the style of David Teniers the Younger (1610-1690). The subjects of his first works are known only from engravings, like those with scenes and characters from the *Commedia dell'arte*, a *genre* very common at the time in Paris where numerous Italian companies presented shows.

● Watteau's interest in the theater, witnessed before by his contemporaries in Valenciennes, intensified in Paris. Here, in 1703, he entered the workshop of Claude Gillot (1673-1722), a painter who specialized in theater sets and costumes, where he stayed until 1707-08. In the same period he devoted his time to studying the works of Titian and Rubens and the prints of Jacques Callot (1592-1635), whose dashing and incisive style later offered Watteau many suggestions for the elaboration of his theatrical subjects.

● His first compositions dedicated to *Comédie Italienne*, the world of theater and common everyday life, date from these years. At the same time, Watteau dedicated himself to interior decoration, works mostly lost but attested by engravings: the four *Seasons* for the home of the duke of Cossé and the decorations dedicated to Oriental characters and costumes in the Castle of de La Muette (engraved in *Oeuvre gravé* of 1731). In these compositions Watteau introduced decorative designs of exotic inspiration, with "Chinese" themes not used in Europe at the time.

● Watteau frequented an artistic environment of painters of theater sets, but also of collectors and print dealers, such as Pierre Il Mariette and his son Jean. Thanks to them he was able to study the works of the great sixteenth and seventeenth century masters, as well as engravings by Bruegel, Rembrandt, Callot, and those of strictly theatrical subjects done by Bernard Picart (1637-1733), Sébastien Leclerc (1637-1714), Claude II Simpol (c. 1666-1716). This circle of artists and art lovers favored a fanciful, bizarre art, inspired by street theater (which continued to have a large following even though the Sun King had closed the *Comédie Italienne* at the Hôtel Bourgogne in 1697) and common everyday life, rather than the official academic manner of painting with its classicizing style and pompous tones.

● Watteau's fame is bound to the narration of the life of love and the gatherings of the aristocratic society of his times. His most famous works are hymns to love, amusement, and genteel conversation in a cocooned world practically unconscious of everything going on outside it. The very titles of his works are an explicit declaration of his poetics. The great majority of his paintings in fact develop manifold versions of the themes described: *Pleasures of Dancing, Enchantments of Life, Country Amusements, Concert, Love at the "Théâtre-Français," Love at the "Théâtre-Italien," Venetian Parties.*

◆ GATHERING
IN A PARK WITH
A FLUTE PLAYER
(1717, Paris, Louvre)
This work has been
compared to
*The Embarkment
for Cythera* because
of the analogy between
certain figures,
but above all for
the sense
of indefiniteness that
characterizes
the landscape and
for which this picture is
considered the first
of a series of works
"suspended in a dream."
The picture presents
a harmonious balance
between groups
of figures, the extension
of the lake,
and the big trees.

◆ JACQUES CALLOT
*The Dances of Sfessania:
Fracischina and Gian Farina*
(1621, Milan,
Civica Raccolta Stampe
Achille Bertarelli).
Callot's etchings
exercised great
influence because
of the original, bizarre,
and inventive nature
of the compositions.
With the technique
of etching he achieved
an enormous liberty of
expression in developing
subjects from the worlds
of theater and parties.

◆ ADVENTURESS
(c. 1712, Troyes,
Musée des Beaux-Arts).
This small painting
on copper was done as
a *pendant* to another,
known by the title
Enchanter and now
in the same museum
in Troyes. Whereas
the figure
of the *Adventuress*
faces toward the left
of the painting where
a young man with a red
cape plays music and
two other enigmatic
figures look on,
the *Enchanter* of the
pendant faces
to the right, engaged
in a serenade
of homage to
two young ladies.

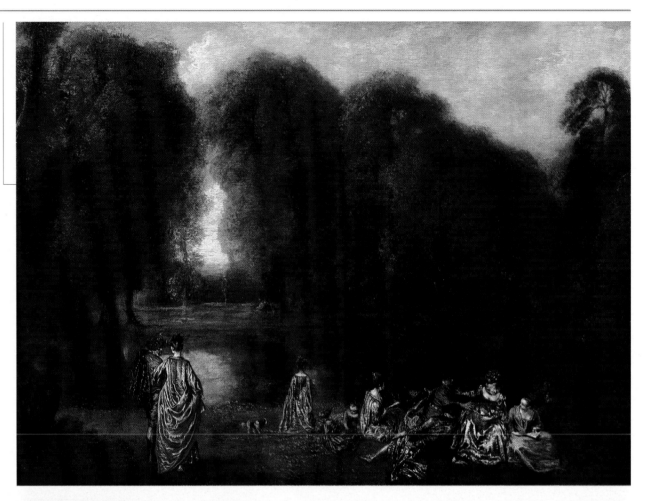

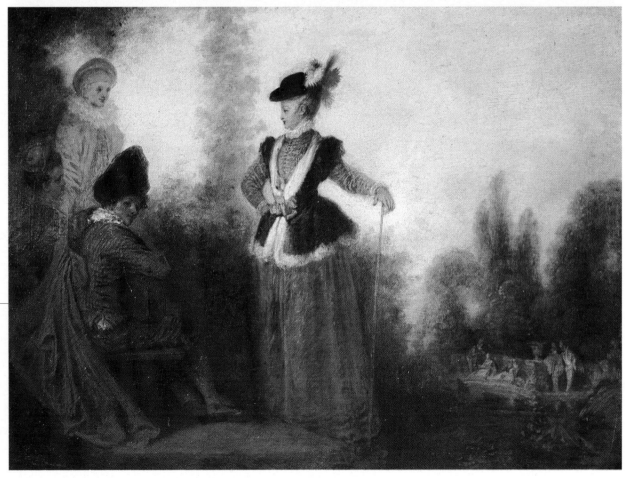

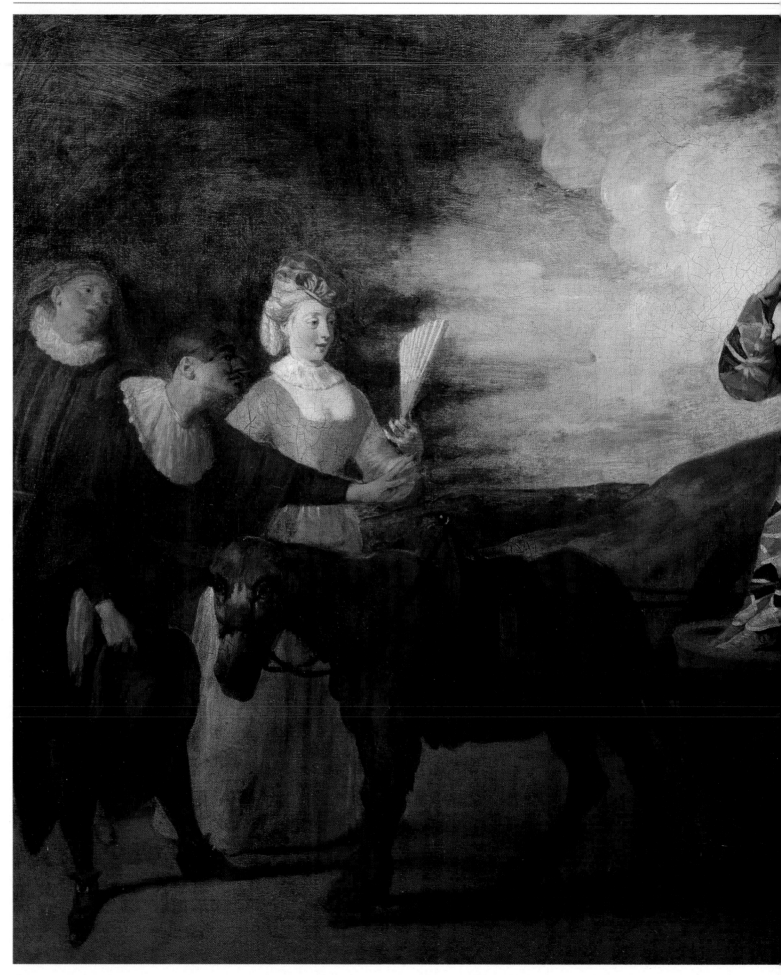

♦ HARLEQUIN EMPEROR
OF THE MOON
(c. 1708, Nantes,
Musée des Beaux-Arts).
The subject of this
bizarre painting is based
on a comedy
by Fatouville,
*Arlequin empereur
dans la lune*, staged
between 1684 and
1719. The construction
of the scene, however,
derives from
an engraving by Claude
Gillot, who specialized
in theatrical subjects,
with whom Watteau had
worked at the beginning
of his stay in Paris,
from about 1703 to
1708. The composition
of the painting plays on
the juxtaposition of
Harlequin sitting
in the gig pulled by
a donkey and the three
Commedia dell'arte
characters in front
of the donkey.

♦ SUBTLE PLAY
OF LINES
The refined
decorations for
the *Hôtel de Nointel
(de Poulpry)*
(1707-08, Paris,
property of Cailleux),
the Parisian building
between rue de Lille
and rue
de Bellechasse, were
commissioned from
Watteau by the first
proprietor
of the building,
the marquis of Nointel.
The decorations
are two series of
panels, oil on wood,
each one with
a different subject
framed to present
a stage effect.
Of the series only
the two panels
shown here have
been found, and
the attribution
to Watteau is not
accepted by all critics.
The other panels are
known only
from engravings.
The subjects
of the decorations seem
to be allusions
to the four seasons,
with strong emphasis
on the light-hearted,
pleasure-seeking
attitudes of the various
figures, as suggested
by Bacchus
in the panel above
and the young couple
in the panel
on the left.
The erotic
connotation of
the latter picture
is expressed by the
pose of the young man
holding the lady's
hand and confirmed
by the bagpipe
hanging below,
a declared symbol
of sensual love.
The title of the
engraving based
on this panel in fact
calls the male figure
a *Seducer*.

A QUICK TOUCH AND STRIVING FOR PERFECTION

Watteau's painting is extremely light and quick, done with swift, delicate brushstrokes. The works on canvas were preceded by numerous pencil studies which reveal an artist almost never content with his results. His great pictures give the impression of a spirit continually attempting to do better: there is never a moment of pause, not even in the secondary elements like the trees or the sky, and one perceives an anxiety to do better, to achieve an ever more refined technique.

● The foggy light one sees in *The Embarkment for Cythera* gives the measure of the extraordinary finesse of Watteau's touch in painting. Restoration of the Louvre version has made more evident the lightness of his stroke and the extreme swiftness of execution. The repeated *pentimenti*, that is the cancelling of an element in the picture by painting over it, reveal an anxiety for continual adjustment typical of the artist. The detail of the trees shows how Watteau painted the leaves: he dipped a long brush in fairly liquid paint and then dabbed it onto the canvas to make the paint squeeze out the sides of the brush.

● A number of Watteau's works were realized in two versions, in the second of which he often developed further certain elements of the first, such as the couple in *Blunder*, reworked in *Love-Fest* (1717, Dresden, Gemäldegalerie). In these variations on the theme Watteau never repeats himself; he tried to evolve in order to make the distinctive characteristics of the picture more eloquent.

● He never wanted to paint according to the rules of the Academy, and his technical knowledge remained modest. While his drawings were based on real situations and subjects, reflecting an attentive observation of reality, in his paintings Watteau was freely inventive, transforming the data of reality into images of pure fantasy.

◆ AN AWKWARD SEDUCER (*Blunder*, 1717, Paris, Louvre) The invention of this unusual couple was reworked by Watteau in various paintings (*Love-Fest, Country Dance, Concert*) and was taken up by his follower Nicolas Lancret (1690-1743). This picture, with a strong psychological impact given the synthetic expressivity of the gestures, was marked by very rapid brushwork, the strokes becoming especially brief in the background and the clothes on the ground.

◆ THE RUSTLE OF THE LEAVES IN THE WIND Unlike the Paris *Embarkment*, in the Berlin picture the trees occupy a central position (see the detail reproduced here) where they fill in the area at the top center. As for the other details, one observes a more minute brushstroke, with a more distinct definition of the margins, making it possible, in this case, to distinguish the individual leaves.

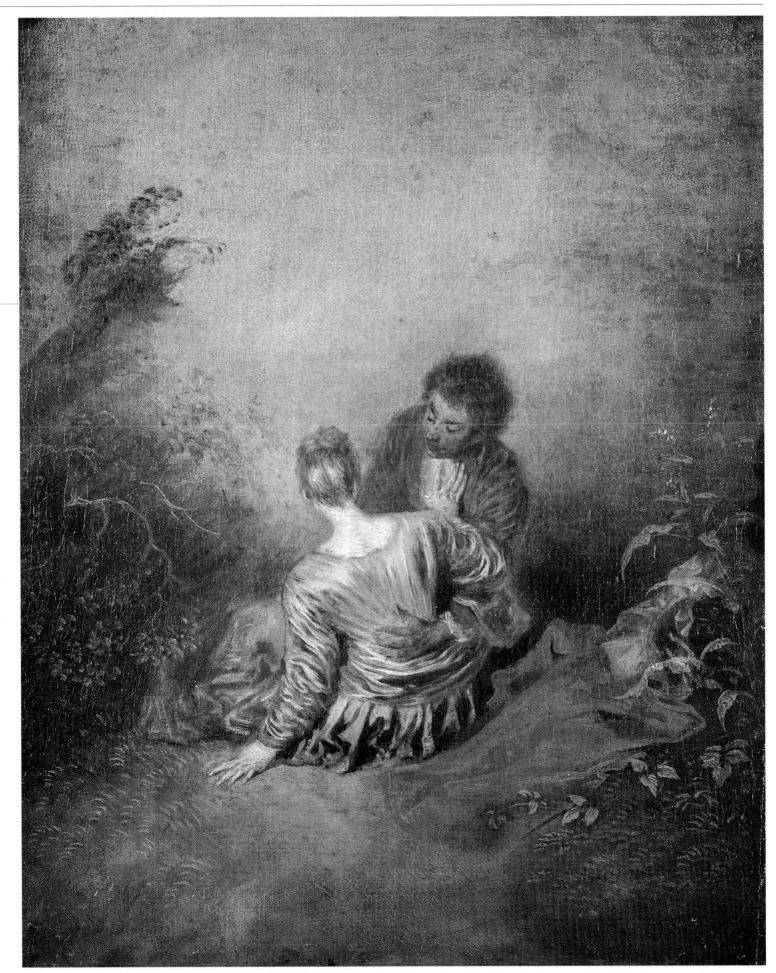

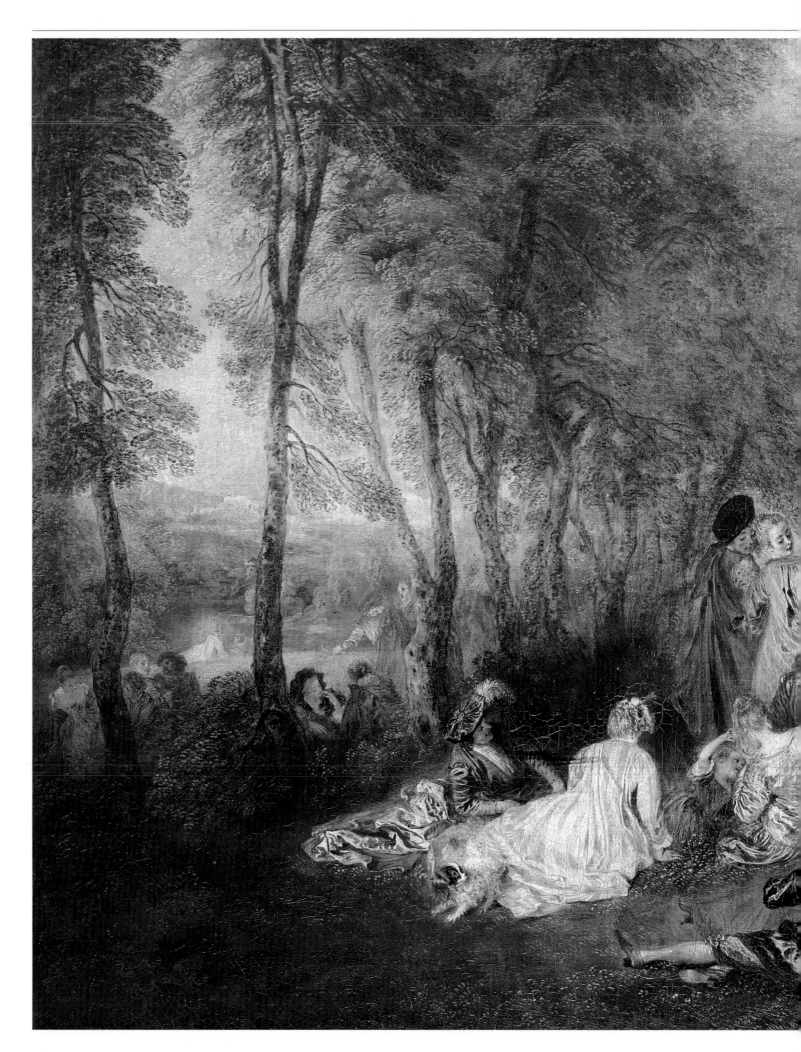

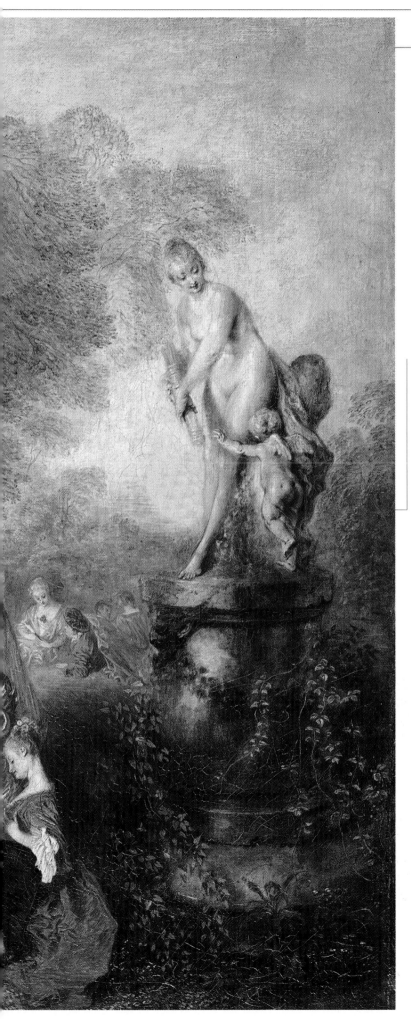

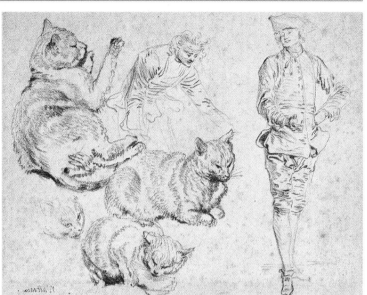

◆ LOVE AT THE CENTER OF NATURE

(*Love-Fest*, **1717**, Dresden, Gemäldegalerie). Once more Watteau develops the subject dear to him of love life, presenting a series of young couples intent on the various phases of courtship in the midst of a splendid landscape. The statue of Venus and Cupid, that Watteau represents in the Charlottenburg *The Embarkment for Cythera*, watches over the gallant lovers, its presence giving a seal of approval to the love-fest taking place at its base.

◆ AN ACUTE OBSERVER OF THE PLAY OF LOVE

Watteau's drawings as well, such as *Two Men and Four Cats* (Bayonne, Musée Bonnat) shown above, reveal his extraordinary capacity to investigate the diverse aspects of reality. As opposed to his paintings, where imagination overcomes realism and idealizes the data of observation in fantastic representation, his drawings reflect immediately the acute recording of reality. In this study, for example, the artist concentrates on the natural poses of the cat and two male figures. In *Two Musicians with Guitar and Flute under a Plant* (Rome, Istituto Nazionale per la Grafica, below) we see a subject often treated by the artist. Here, once again, the theme of musicians is associated with that of a couple, who presumably present a loving attitude. In particular, the male figure seems to be inspired by that of *Mezzettino with a Guitar*, at the center of numerous Watteau paintings.

SEDUCED BY ACTORS, SINGERS AND DANCERS

On his return to Paris in 1709 after a stay in Valenciennes, Watteau devoted himself prevalently to works inspired by the theater, both Italian and French. His numerous paintings were based on a figurative repertory then widespread in the northern countries, known especially through engravings, but also by direct vision of Italian acting companies specializing in improvisation.

● One of the most suggestive of this series is *Gilles and Four Other Characters of the Commedia dell'arte*, probably painted between 1717 and 1719. The disquieting sensation that the picture inspires is due to the isolation and the monumental pose - given by the view from below - which emphasize the subject's melancholy expression and his awkward stance.

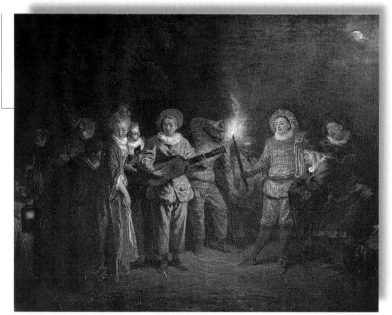

◆ LOVE AT THE THEATRE-ITALIEN (1718, Berlin, Staatliche Museen). The painting is a *pendant* to *Love at the Théâtre-Français*. Its special lighting, given by the moon, a torch, and a candle, recalls the "fine night scenes" of the Italian playwrights.

● The format of the painting (184x149 cm) and the emphasis on the figure of Gilles have led to the hypothesis that it was intended as a sign for a theater. In addition to *Gersaint's Sign* (1720), paintings produced for performances include *Allegory of the Union between Comedy and Music* (1715?) and *Pomona and Cherub* (c. 1715).

● The positions of the figures in some of Watteau's works reveal his direct contact with dance, considered a very important art form in seventeenth and eighteenth century French culture. Beginning in 1700 dancing was radically changed by Parisian dance expert Raoul Anger Feuillet's invention of a system for recording the steps. The dance of this period is characterized by a continuous fluid movement, impossible to set in separate figures. And it is precisely these light, mobile arabesques and positions that Watteau caught with his swift and airy brushwork.

◆ THE MELANCHOLY OF THEATER In *Gilles and Four other Characters of the Commedia dell'arte* (1717-19?, Paris, Louvre) the monumental treatment of the timid and awkward subject creates a sort of psychological estrangement, emphasizing the sense of inadequacy and deficiency and thus the melancholy aspect of the figure.

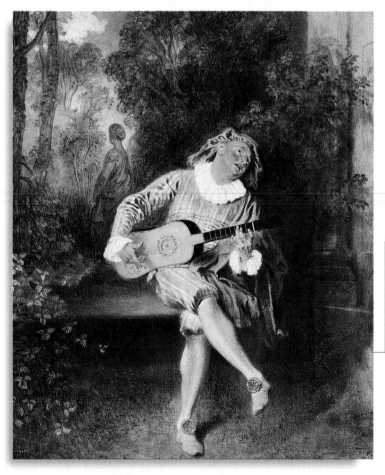

◆ MEZZETTINO (1717-19, New York, Metropolitan Museum). The stock- or mask-character Mezzettino the guitarist, recognizable as one of the figures in *Love at the Théâtre-Italien*, was used many times by Watteau. This character was introduced in France by the Italian comedien Angelo Costantini.

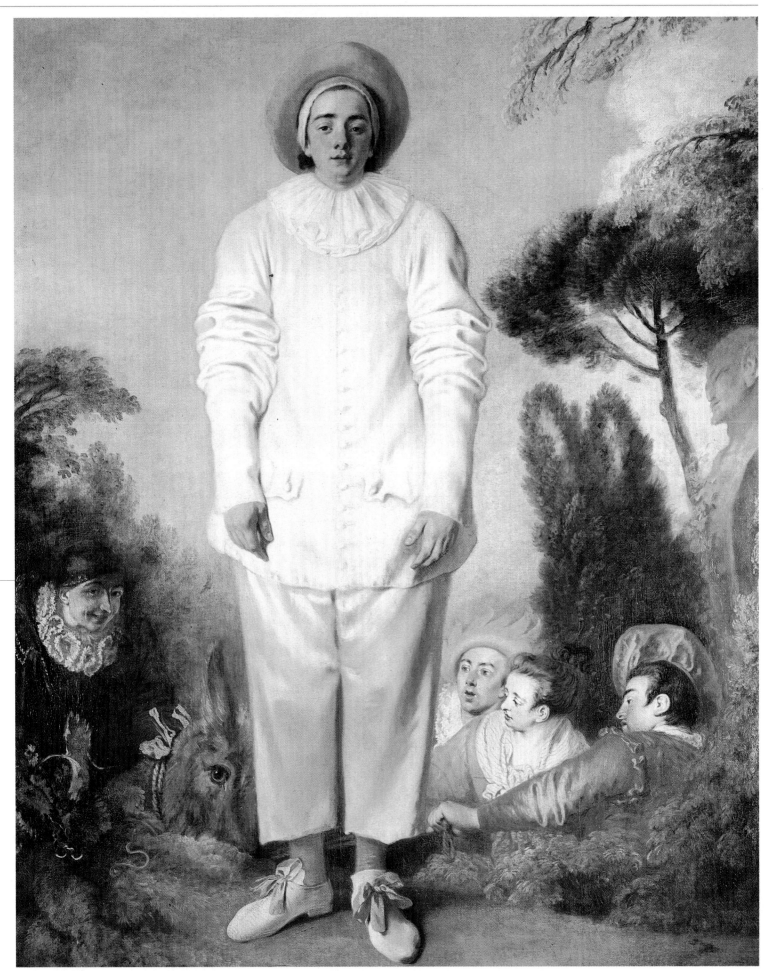

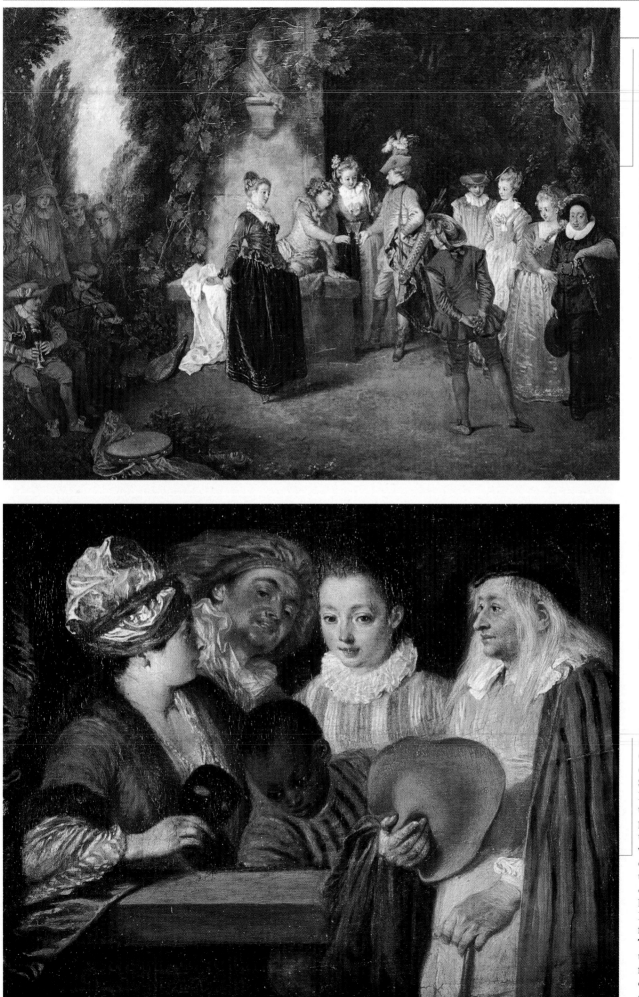

◆ REPRESENTATION
OF LOVE
A *pendant* to the Italian
one, Watteau celebrates
*Love at the Théâtre-
Français* (1718, Berlin,
Staatliche Museen).
Critics are divided
on the title of the play
represented on stage
here, but they agree
that it refers to a theme
of love and Bacchanal
drunkenness, alluded
to by the vine-crowned
young man toasting
with a suitor.

◆ AWAITING THE DANCE
The step
of the *Indifferent*
young man (1717,
Paris, Louvre), a very
famous personage
created by Watteau, who
forms a couple with
the female figure *Finette*
(1717, Paris, Louvre),
is suspended in
a position of languid
waiting, seen in
the explicitly fixed dance
step. The "indifference"
that the personage
presents, thus, is only
his studied pose, one of
extremely artificial
"naturalness," as seen
in many of the figures in
Watteau's paintings.
The picture has been
seriously damaged
by poor restoration
and repainting.

◆ PORTRAITS
OF MASK-CHARACTERS
(*Masquerade*, 1717?,
St. Petersburg,
Hermitage). Similar
to many other Watteau
paintings, this one has
undergone repaintings
which have altered their
quality. The models for
the four mask-
characters represented
here were perhaps
French theater actors,
friends of the artist.
The presentation of
the subjects is unusual
for Watteau and brings
out the portrait aspect
of the painting.

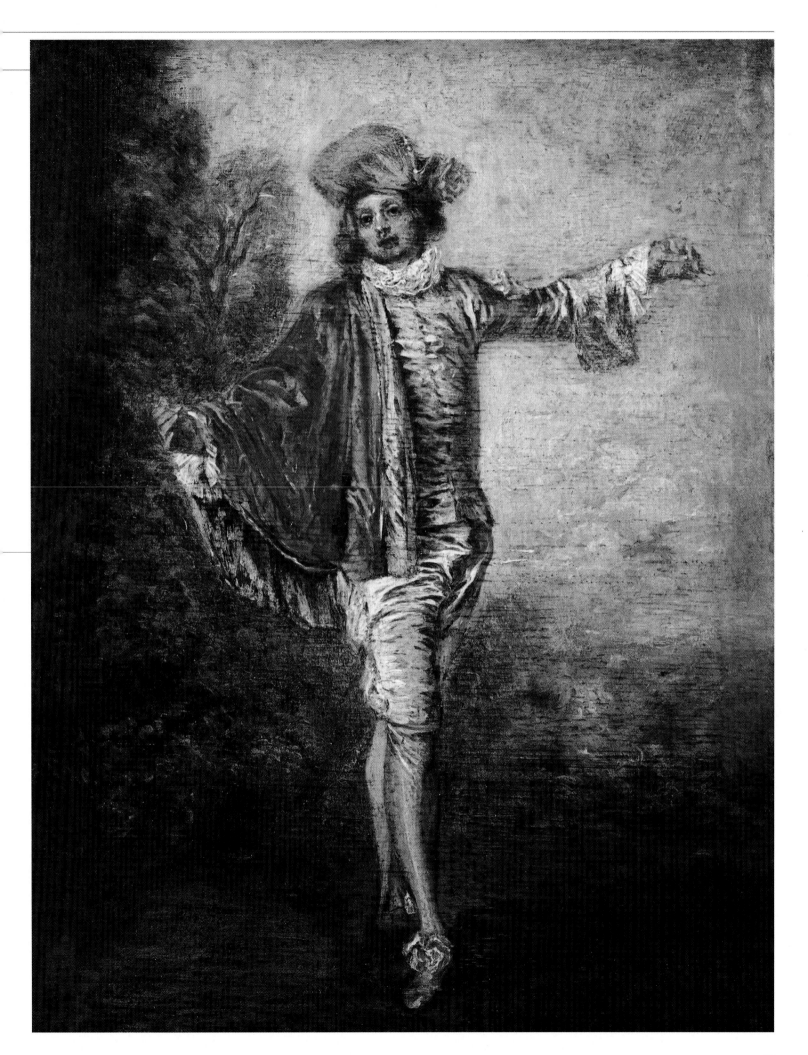

MAKING CONVERSATION

The *scenes of gallantry*, a pictorial type initiated by Watteau, constitute a new genre in which the tradition of great landscape and story painting takes on a more intimate, theatrical dimension. This celebration of love and musical and worldly entertainment with, instead of mythological or historical heroes, anonymous ladies and gentlemen flaunting all the gallantry and elegant stylish costumes of the time, led to severe criticism of Watteau's painting by the supporters of the Academy.

● *Conversation* as a literary form, a favored means of communication in seventeenth-eighteenth century France, the fruit of a transformation of the ideals of the aristocracy and its need to find a new self-image different from the cultural models of the past, became Watteau's preferred artistic form; he captured it by observing the social behavior of that social class and turned it into the metaphor of an artistic identity detached from educational precepts and acade-

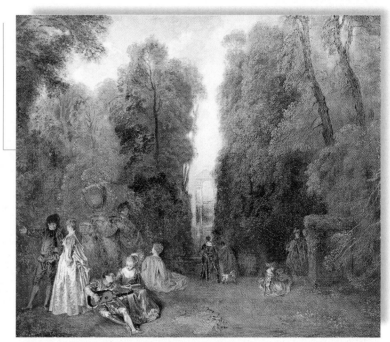

◆ PERSPECTIVE (1715, Boston, Museum of Fine Arts). In this painting Watteau concentrated on the "architectural" construction of the landscape, explicit in the title. Both halves of the picture are in fact almost entirely filled up with a thick row of tall trees, with multicolored leaves, which close up in the background producing a telescopic-like view with a building in the center.

mic tradition. His gallant compositions play out like a free dialogue between the various characters, each one participating in his own way in the collective communication through the exchange of words, songs, embraces.

● Watteau's work, by his explicit illustration of such forms of social behavior, shows his deep reflection on the subject of oral language. Conversation, during the period the painter was active, was

◆ VENETIAN PARTIES (1717, Edinburgh, National Gallery of Scotland). The costume of the figure in the foreground on the left - according to some critics a Pantaloon (the typical Venetian mask-character) costume, according to others an Oriental style - is the origin of the Venetian connotation of this *festa* or party.

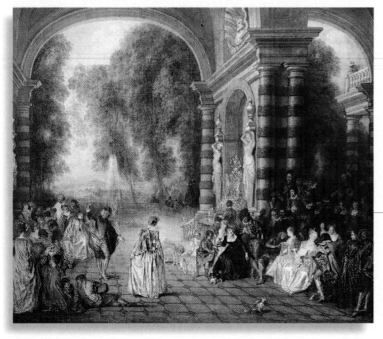

◆ THE PLEASURES OF DANCE (1717, London, Dulwich College). The open architectural view dominates the picture. An X-ray examination of the painting has shown another view, inspired by Sant'Andrea al Quirinale in Rome. The imposing two-colored columns have been associated with the work of the French architect Brosse as well as the environments in paintings by Veronese.

conceived as a civilizing agent, and in Watteau's work it is enriched by another element: freedom from written representation. The dialogues in Watteau's pictures speak directly to the observer's spirit, without mediation.

● One feels a profound sense of freedom in this way of treating *conversation*: there is no shadow of edifying or moral messages, only the pleasure of entertainment.

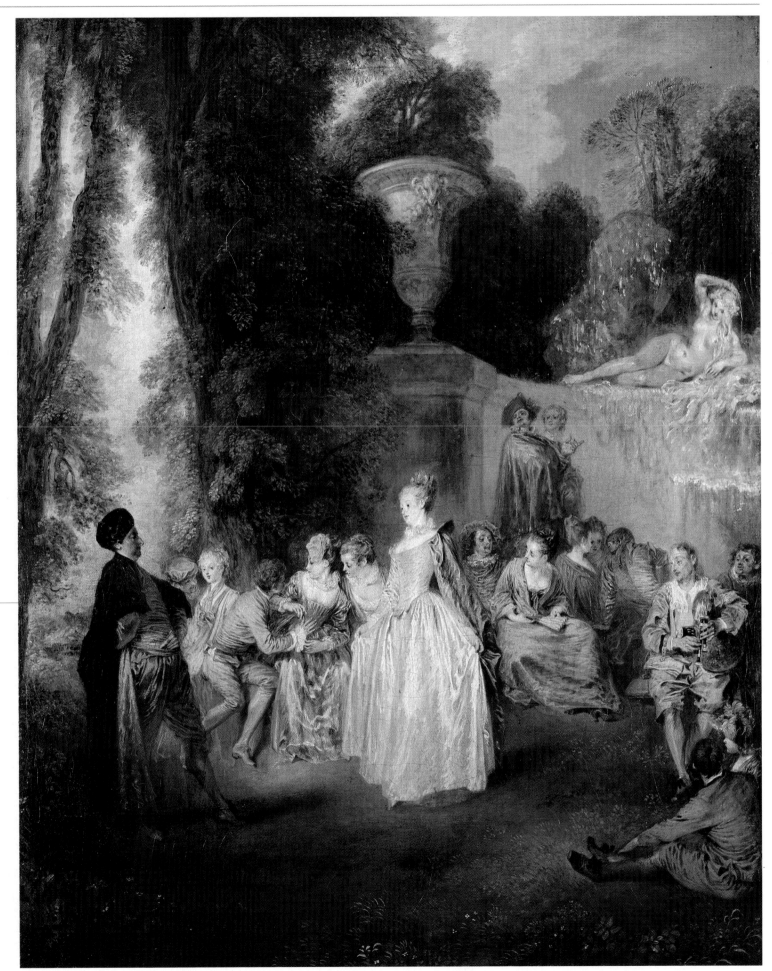

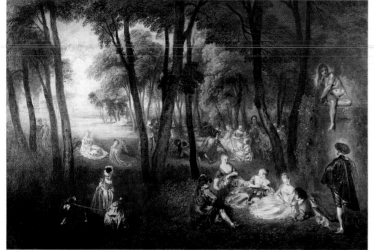

GALLANT HUNT

Hunting was one of the preferred amusements of eighteenth century aristocratic society: free of any utilitarian function, it was the ultimate in recreation. Then again in his *Hunt Meeting* (1720, London, Wallace Collection) Watteau opted for a gallant vision of this activity that, on the contrary, should by definition be rustic.

The painter presents the aspects of hunting that emphasize its social dimension, depicting "civil" behavior involving conversation and exchanges of affection and feelings between the various characters in the picture.

BETWEEN THE CONCERT AND LUNCHEON

The painter goes beyond the Venetian suggestions and infuses the personages in his *Country Amusements* (1718?, London, Wallace Collection) with modern characteristics. The roses the girls put on, the dances, the children playing with the dog, the walks, and the conversations between the couples create an atmosphere rife with social characteristics of the time. The modern representation and the curious light that surrounds the figures, setting them off against the background, remind us of a later picture of young men and women in a landscape: Manet's *Dejeuner sur l'herbe* (1863, Paris, Musée d'Orsay).

CONCERT BETWEEN STAGE AND NATURE

In *Enchantments of Life* (1718?, London, Wallace Collection), Watteau has created an unusual composition. The principal scene develops on a sort of porch with tall columns on the sides (which appear to be very similar to those of *Venetian Parties*). The architecture is open toward the background, letting our gaze proceed in the distance toward the natural landscape. The center of the picture is occupied by a lute player, with, on the left, a group of figures listening rather distractedly. Among them, we can easily recognize Mezzettino.

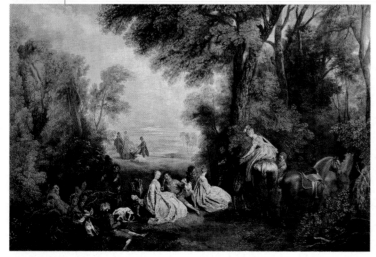

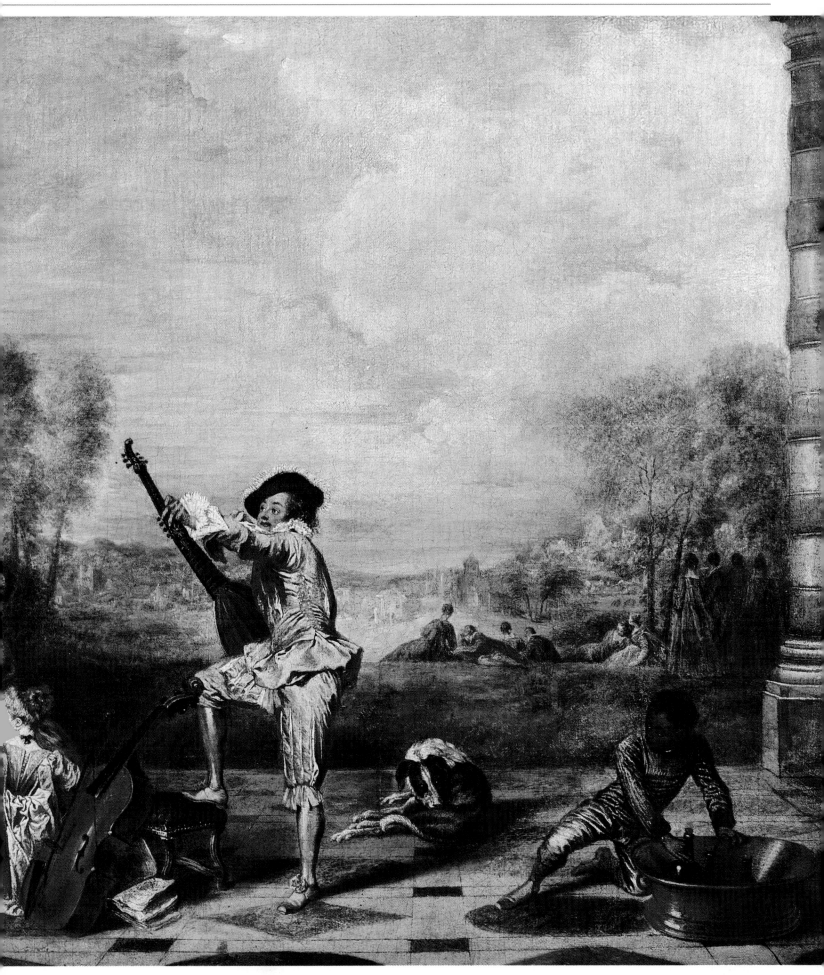

ART FOR AN AUDIENCE

During his formation in Valenciennes in the *atelier* of the painter Jacques-Albert Gérin and even more, later, during the first years of his sojourn in Paris, Watteau became acquainted with the so-called *genre* paintings of the seventeenth century Dutch artists. While he was working as a copyist in the workshop of a painter-merchant on the Notre-Dame bridge he saw paintings by Gerrit Dou (1613-75), David Teniers, Adriaen Brouwer (1605-38) and acquired experience in creating works on subjects taken from the everyday life of common people.

in the workshop scene depicted. Watteau did not attempt to express judgment on the pictures on the walls (in fact they are not copies of recognizable works but assemblages of different paintings), but rather to establish a relationship between two different systems of communication: painting and worldly dialogue, read in its social dynamics. Thus there is no affirmation of a definitive, conclusive image, and - significantly - in the center of the picture appears an open door which refers back to the picture's immediate function of communication.

● *Gersaint's Sign* is the first example of artistic representation

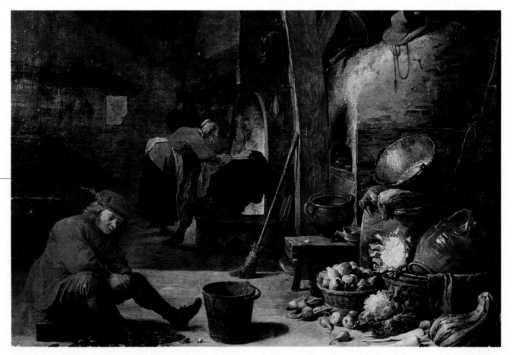

◆ DAVID TENIERS THE YOUNGER *Kitchen Interior* (Madrid, Prado) Teniers' work spread in Netherlands the popular style of genre painting inspired by common everyday life. In this picture one appreciates the traditional ability of Flemish artists of reproducing with minute objectivity true still lifes within a painting. Almost half of the composition shows foods and utensils of the time, presented in a disorder created to reinforce the realism of the scene.

◆ COOK (SCULLERY-MAID) (c.1703, Strasburg, Musée des Beaux-Arts). This painting is explicitly related to the Northern tradition of genre painting with which Watteau had become familiar during his apprenticeship in Paris. One sees that the French painter was not only attentive to faithfully reproducing the copper pans and the other objects in the messy kitchen, but he also grasped the human dimension of the protagonist, isolating her in the center of the scene and illuminating her with a warm light.

● Such pictures were very popular in seventeenth century Europe. The specialists in the sector were the northern painters (Dutch and Flemish) who travelled throughout Europe, establishing a real colony in Rome, spreading the idea of purely realistic topics with popular subjects which were highly successful with the public. During the seventeenth century the group of art-lovers and collectors grew enormously, including social classes excluded from the art market before then.

● From then on, Watteau devoted himself primarily to aspects of the daily life and pastimes of aristocratic society, including, as mentioned above, *conversation*. Watteau translated this into painting in one of his most important works, *Gersaint's Sign* (1720): in it, pictorial art is compared and mixed with the art of conversation, represented by the behavior of the personages

dedicated to the inside of a painting shop. Paintings of interiors including pictures were done later, in the mid-eighteenth century, by Giovan Paolo Panini (1691-1765): the most famous is the *Gallery of Cardinal Silvio Valenti Gonzaga*, where one recognizes certain famous paintings, such as the *Assumption* by Annibale Caracci (1560-1609).

● The environment depicted by Panini does not correspond to the Cardinal's real gallery, but was inspired instead by the one used as a model from 1703 on, the Galleria Colonna in Rome, the first important collection of pictures and statues prepared with a criteria for exposition, uniting the study of the placement of art works with the architectural decor. A similar composition is seen in Panini's other painting, *Views of Modern Rome*.

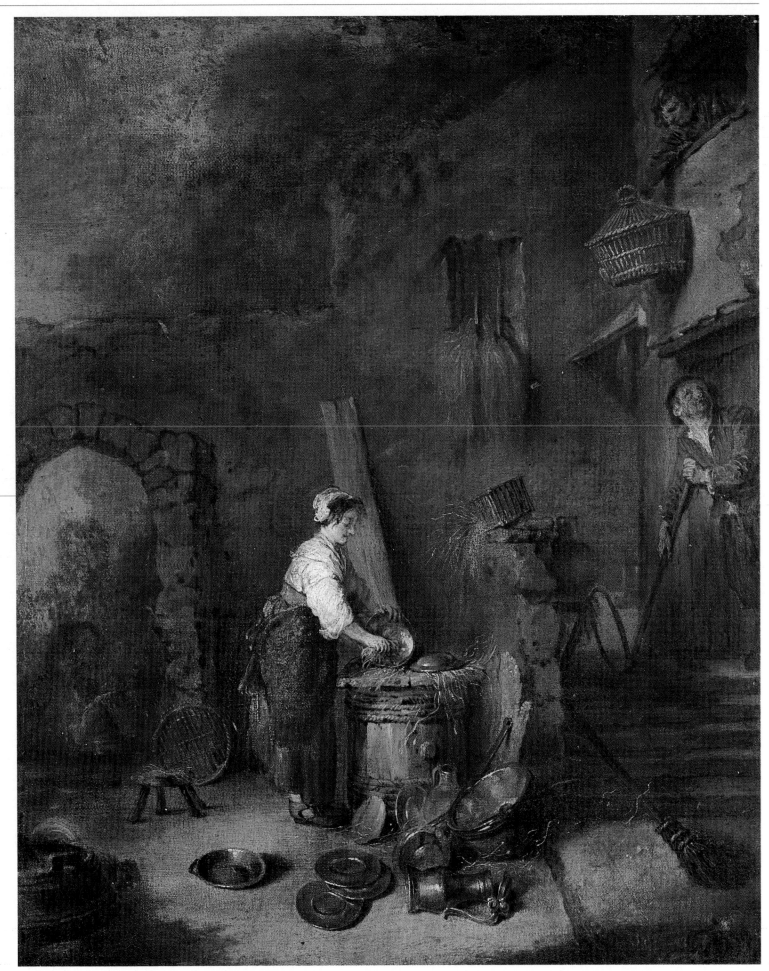

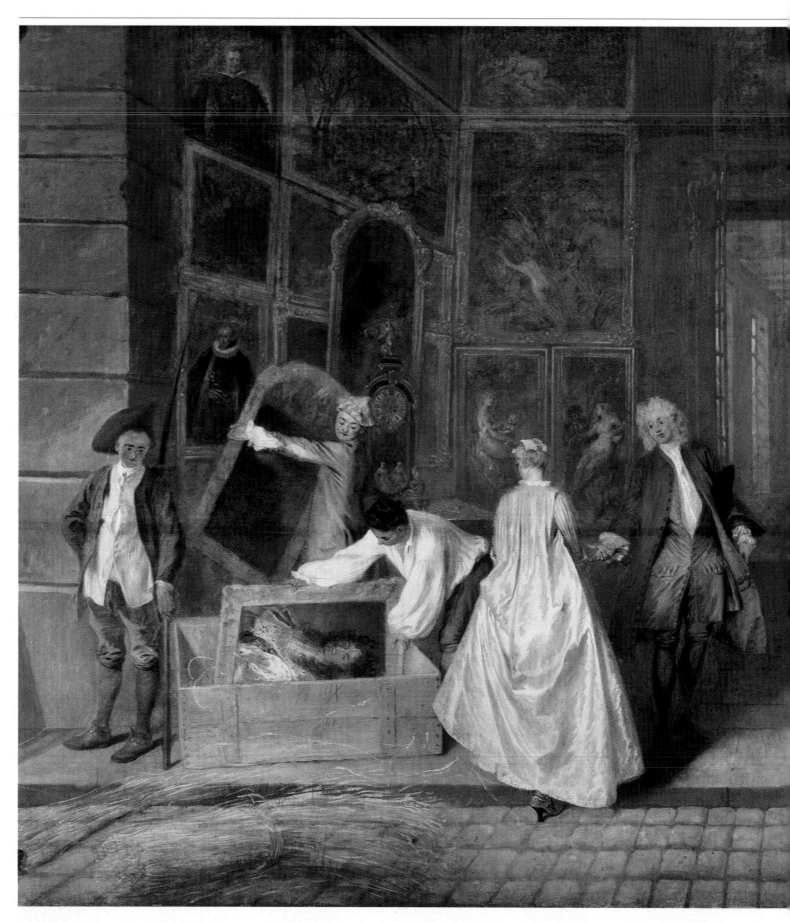

◆ CONVERSATION
TRANSLATED INTO IMAGE
"On his return
to Paris he [Watteau]
came to ask me if
I would allow him,
to flex his fingers,

to paint a sign
that I could hang
outside." This is how
Watteau's friend,
the proprietor of
a painting shop
on the Nôtre-Dame

Bridge, recounts
the origin of
Gersaint's Sign
(1720, Berlin,
Charlottenburg Castle),
indicating that it was
originally intended

to be used as a sign.
The work was
interpreted as Watteau's
artistic testament.
The painter, dressed
like a gentleman
in the center

of the picture,
invites the young lady
to stop looking
at the portrait
of the Sun King,
which is being
packaged, and

to go with him
to see more
modern pictures
of landscapes
and gallant subjects,
those admired
by true art experts.

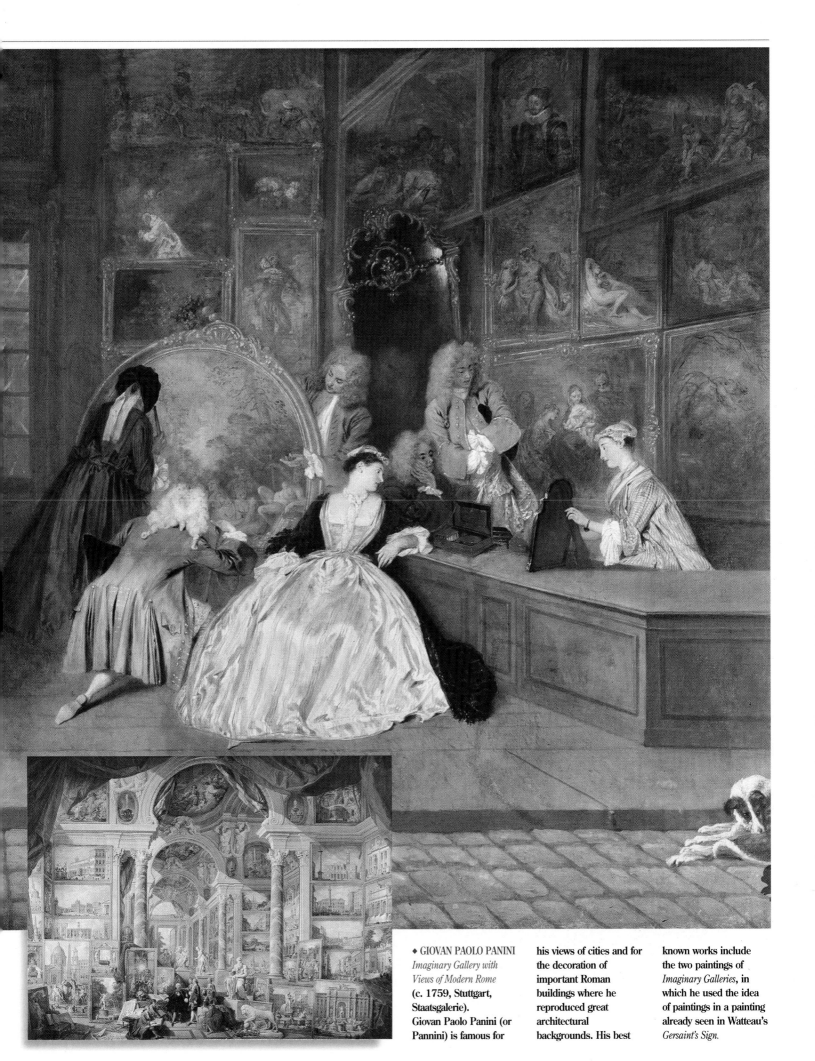

◆ GIOVAN PAOLO PANINI
Imaginary Gallery with Views of Modern Rome
(c. 1759, Stuttgart, Staatsgalerie).
Giovan Paolo Panini (or Pannini) is famous for his views of cities and for the decoration of important Roman buildings where he reproduced great architectural backgrounds. His best known works include the two paintings of *Imaginary Galleries*, in which he used the idea of paintings in a painting already seen in Watteau's *Gersaint's Sign*.

MYTHOLOGICAL TALES

Nymph Surprised by a Faun (or *Jupiter and Antiope*) is evidently based on the painting of Titian as well as that of Anton Van Dyck (1599-1641). The reference to the Flemish painter is visible in the vibrant play of light on the drapery and in the nymph's graceful face; her soft figure and above all the landscape, illuminated by the warm light of sunset filling the sky with intense color, demonstrate the lesson of the Venetian painter.

● The influence of Venetian painting is observed also in *Venus Disarming Cupid*, where the goddess reminds us of a design by Veronese, now in the Louvre and in the past in the Crozat collection, studied by Watteau between 1710 and 1715. The Venetian sources are grafted onto an assimilation of Rubens-like color, which was a fundamental reference for his artistic research.

● The works in which Watteau treats mythological subjects, including *Seasons*, painted for Crozat in 1715, and *The Judgment of Paris*, now in the Louvre, reveal his interest in nude studies. On this theme, the artist's choice of long sinuous bodies demonstrates his knowledge of not only Venetian painters, but also those of the sixteenth century School of Fontainebleau, in particular Primaticcio (1504-1570).

● In these *tales* Watteau inserts himself in the wake of the great Italian and northern pictorial traditions, emphasizing particularly the landscape and chromatic elements of the composition: the palette is at the same time more delicate and more intense, and the light changes color from one plane to the next, enriching the picture with diverse fantastic atmospheres.

◆ THE JUDGMENT
OF PARIS
(1720, Paris, Louvre)
The painting was done
in the artist's full
maturity and reveals
influences traceable
to Primaticcio.
The brushwork,
however, is totally
different from
the tradition of French
Mannerism and
the incomplete forms,
the movement in
the composition,
the indefinite
background, led to talk
of a purposely
"unfinished effect."
In the center of
the scene Venus, with
Cupid at her feet,
receives the apple of
victory from Paris, who
is accompanied by
Mercury. The armed
figure on the right has
been identified as
Minerva, and there is
a nymph in the sky.

◆ NYMPH SURPRISED
BY A FAUN (JUPITER
AND ANTIOPE)
(1715, Paris, Louvre).
The numerous
preparatory drawings
for this painting show
how deeply Watteau
studied the subject and
effected personal
elaborations, despite
the direct references
to Titian and Van Dyck.
The position
of the nymph's left leg,
with the foot pointed
toward the viewer,
creates an oblique line
connecting the interior
of the composition with
the exterior. The dark
tones have been
accentuated by
subsequent repaintings.
The nymph's white body
in soft abandon
contrasts with the dark
figure of the satyr,
reaching out in
a gesture full
of restless energy.

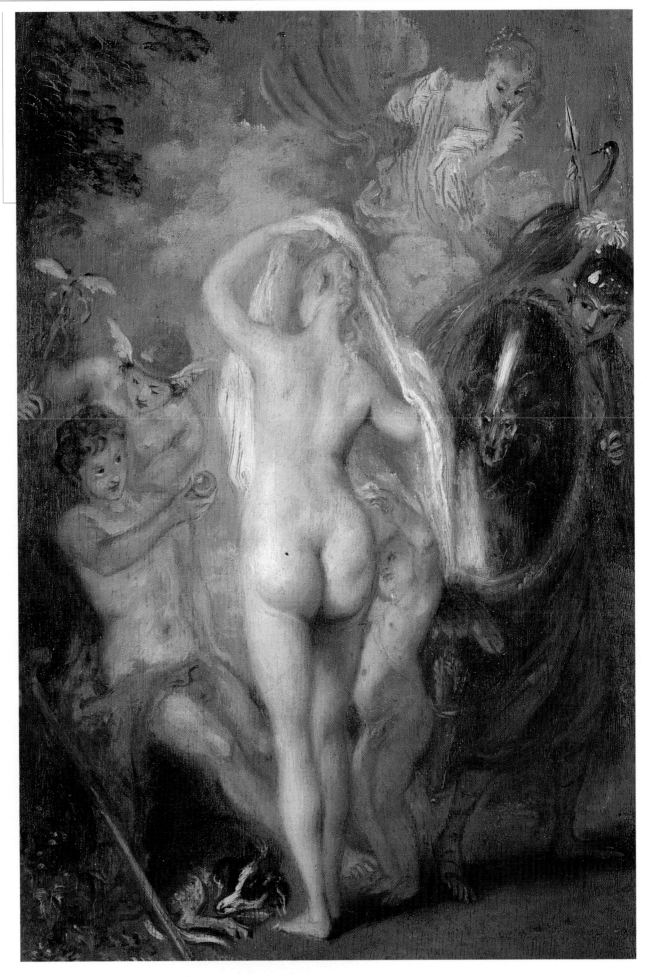

PRODUCTION

◆ VENUS DISARMING
CUPID
(1715, Chantilly,
Musée Condé).
Here Watteau treats
the mythological
subject in an extremely
lively manner.
The picture,
with little Cupid
climbing up on
his mother,
who is
holding

his bow in
the air far
from the
arrows,
presents
a vivacious scene,
played on
the alternating
contraposition of
diagonal lines (the legs,
the trunk of the body,
the arms). The gesture
has been masterfully
studied to fill in
the space on the side
with a light touch.

◆ A LADY
AT HER TOILET
(1717?, London,
Wallace Collection).
This painting became
a model for subjects
inspired by light
erotism. With great
ability Watteau balances
the sensual charge
of the woman
taking off her
nightgown and
the intimate

atmosphere
of the scene,
with the maid
behind her and
the little dog on the
bed. The structure of
the painting (of which
the four corners were
painted later - not shown
here) plays on the
diagonal of the bed
contraposed to the
sinuous figure of the
woman's body, based on
Rubens.

HIGH-SPIRITS IN THE PICTURES, TORMENTS BEHIND THEM

Watteau – born in 1684, died in 1721 – lived during the reign of Louis XIV, the Sun King, and Voltaire included him by right in his catalogue of "famous artists" of the *Siècle de Louis XIV* (century of Louis XIV) (Berlin, 1751). Although he has passed into history as the painter of *fêtes galants*, narrator of the *sweetness of living*, he lived in times of severe crisis, with wars and natural calamities: the Parisian famine following the terrible winter of 1709 and the plague in Marseilles in 1720 were dramatic milestones of the era. The experiences of the countryside and the cities scoured by soldiers are gravely expressed in his works with military subjects (such as *Soldiers' Camp*, painted around 1710), some preserved only in engravings. In Watteau's 37-year life there were only six or seven years of relative peace, the period of greater tranquillity being from 1715 to 1723 during the regency of Philip of Orléans.

● His works with popular subjects reveal the influence of the pictorial genre that was so widespread in seventeenth century painting and first represented by Flemish artists: the *bambocciate*. The term came from the nickname given to the

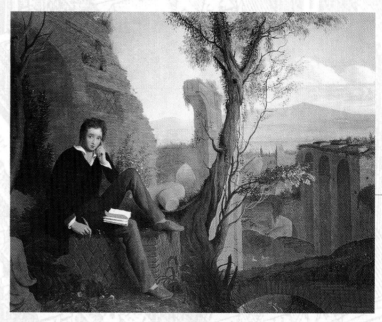

Dutch painter Pieter Van Laer (c. 1592-1642), active in Rome in the first half of the seventeenth century, because of the figures similar to the chubby simpletons (*bambocci*) that populated his pictures of small scenes of daily life in humble and popular contexts.

● One of the characteristic usages of the eighteenth century in Europe was the so-called *Grand Tour*. The cultural formation of the aristocracy of the era was not possible without travel and a sojourn in the Italian cities rich in art, both classical and modern. Venice, Florence, Rome, Naples and Sicily were fundamental stops on this cultural itinerary.

● The phenomenon of the *Grand Tour* was related to that of *souvenirs*, comprising both miniature reproductions of individual monuments and pictures including copies of certain works. Watteau's highly original *Gersaint's Sign* testifies to the spread of this genre.

● The environment of music and theater represented by the painter knew a time of particular brilliance. In this period Johann Sebastian Bach (1685-1750), one of the greatest composers of all times, created his works, while France saw the diffusion of the national opera of Jean-Philippe Rameau (1683-1764). Theater had by then received a strong stimulus from the Italian *Commedia dell'arte*, which had numerous followers in Paris notwithstanding the ban ordered by Louis XIV.

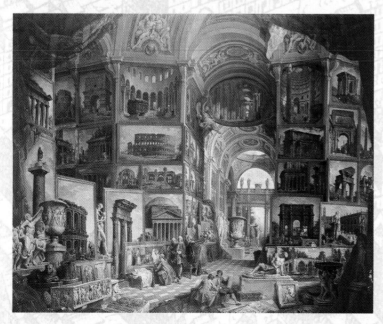

◆ CLAUDE GILLOT
The Fall of Master André
(Paris, Louvre).
The painter Claudé
Gillot specialized
in representing
theatrical subjects
and made costumes and
sets for the theater.
The scene of the action
in this painting
is similar to
a true stage.

◆ SEVERN
*The Poet Shelley
at the Caracalla Baths*
(1845, Rome,
Keats and Shelley
Memorial House).
The eighteenth century
phenomenon of the
Grand Tour continued
intensely into the
nineteenth century, as
attested by this painting
of Shelley among the
ruins of ancient Rome.

◆ SOLDIERS' CAMP
(TEMPORARY CAMP)
(c. 1710, Moscow,
Pushkin Museum).
The reign of Louis XIV
(portrayed in the medals
shown at the top left on
the facing page) was
characterized not only by
the rarefied atmosphere
of Parisian aristocratic
society, but also by the
harsh reality of the war
that devastated northern
France. Sensitive to his
times, Watteau fixed this
reality on canvas.

◆ GIOVAN PAOLO
PANINI
*Imaginary Gallery with
Views of Ancient Rome*
(c. 1756, Stuttgart,
Staatsgalerie).
The eighteenth century
was also the century
of great archaeological
discoveries, including
Herculaneum (1738)
and Pompei (1748).
The passion for antiquity
went hand in hand with
the need for graphic
and pictorial
documentation of
classical monuments, as
shown in Panini's gallery.

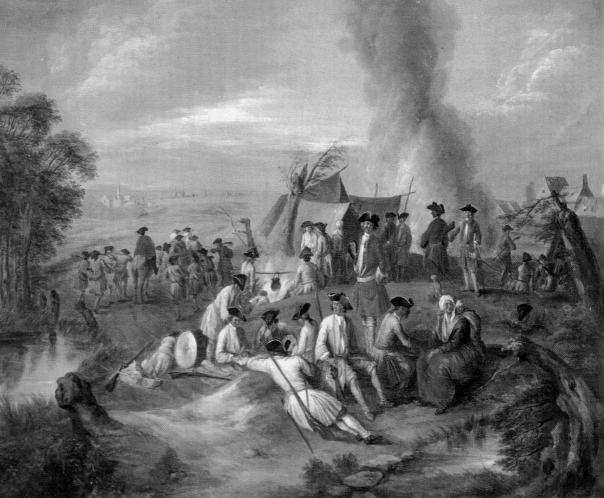

THE FATAL LIGHTNESS OF ROCOCO

Watteau's only pupil was the son of the sculptor Antoine Pater, Jean-Baptiste Pater who was, however, much inferior to his teacher. Watteau exercised a decisive influence on French painting in the second half of the eighteenth century, but not so much in regard to technique as to subjects, which provided a mirror of a lively society and an aristocratic class that seemed to be consuming the last moments of the "sweetness of living" before the fatal era of the Revolution.

● The artists who frequented Watteau's circle included the great Italian portrait painter Rosalba Carriera (1675-1757), whose pastels were very much in demand in Paris. During her stay in Paris in 1720-21, Rosalba Carriera met numerous artists including Watteau and Nicolas Vleughels (1668-1737), who probably introduced them.

● Watteau's painting, purposefully very different from the courtly and academic style of, for example, Charles Le Brun (1619-90), the most representative exponent of the solemn ostentation of the reign of Louis XIV, pictured subjects of contemporary life in a refined style. The lightness and vitality of his art exercised a strong influence on the work of later French artists, such as

François Boucher (1703-70) and Jean-Honoré Fragonard (1732-1806), genial interpreters of the taste for Rococo that received its first fundamental contribution in Watteau's work.

● He also achieved remarkable influence in Spain, as witnessed by certain paintings by the genial early nineteenth century artist Francisco Goya. Goya's rapid painting, lit up by sudden flashes of light, and his sensibility for subjects of contemporary life and theater reveal an affinity with Watteau's poetics.

● The numerous engravings that spread knowledge of his works after his death testify to Watteau's good fortune. His friend Jullienne promoted their reproduction. At the beginning he emphasized the drawings, which came to be called the *Recueil Jullienne* (the *Jullienne Collection*) comprising 351 plates; then he had engravings done of the paintings, collected in the *Oeuvre gravé*, comprised of 144 reproductions. Watteau had many followers, generally less gifted. However, noteworthy were Nicolas Lancret (1690-1743) and Sébastien Leclerc in France, Mericer in England, and Quillard in Spain.

◆ JEAN-BAPTISTE PATER
Bathers
(c. 1721, Paris, Louvre).
Watteau's only direct pupil, the son of the sculptor *Antoine Pater* portrayed by Watteau in the oval portrait shown on the facing page, (c. 1716, Valenciennes, Musée des Beaux-Arts), was a modest painter. This picture of *Bathers* shows a certain banalization of the atmosphere compared to those created by his teacher.

◆ JEAN-HONORÉ FRAGONARD
Playing Blindman's-Bluff
(Washington, National Gallery).
Watteau's views on love and nature reach the height of brilliance and serenity in the paintings of Fragonard, who treated the themes with excellent technique.

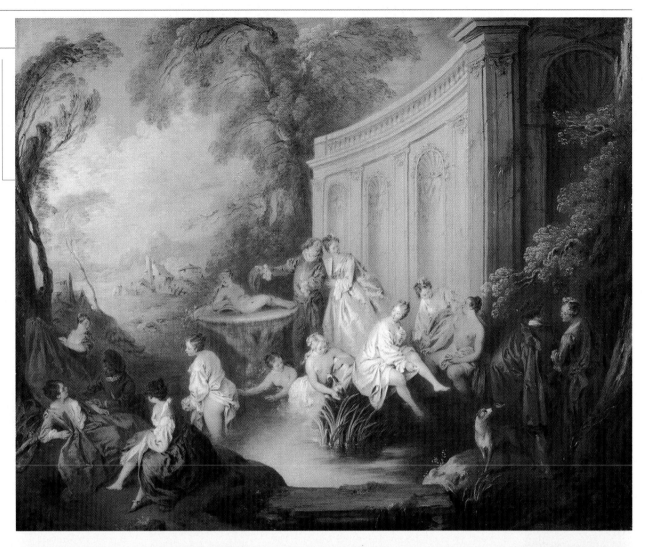

◆ FRANÇOIS BOUCHER
Surprised Bather
(Moscow, Archangel Palace).
The sensuality expressed in Watteau's *mythological tales* started a genre of erotic painting that became very popular in the eighteenth century. Boucher was one of the principal exponents of the genre. In this painting both the subject and the general composition are reminiscent of Watteau's work.

◆ FRANCISCO GOYA Y LUCIENTES
Blindman's-Bluff
(1788-89, Madrid, Prado).
Goya grasped the lesson from Watteau with great sensitivity. This picture seems to be a metaphor of the game of an aristocratic society that lived out of touch with the times and blindly continued its fatuous merry-go-round.

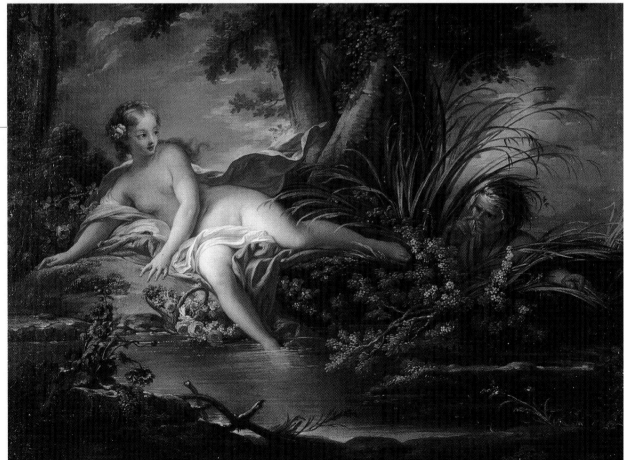

THE ARTISTIC JOURNEY

For a vision of the whole of Watteau's production, we have compiled a chronological summary of his principal works. Since he did not date his paintings, the order followed is approximate

◆ COOK (SCULLERY-MAID) (c. 1703)

This painting, done at the beginning of Watteau's painting career, shows his interest in subjects taken from common everyday life that were so popular from the seventeenth century on, especially in the production of northern European painters. Watteau took particular care in the representation of the still life near the cook's feet as she cleans the copper pans with straw.

◆ DECORATIONS FOR THE HOTEL DE NOINTEL (1707-08)

Watteau also did other interior decorations in addition to those at the Hôtel de Nointel (of which two panels in the Castle of La Muette and the *Seasons* done for the home of the duke of Cossé are all that survive). In these scenes he developed a type of decoration that was typically Rococo, based on intertwined lines and elements of Oriental origin.

◆ HARLEQUIN EMPEROR OF THE MOON (1708?)

The painting is based on one by Claude Gillot, in whose Parisian workshop Watteau worked from about 1703 to 1708. Inspired by the theatrical world, the scene develops on both sides, united by the figure of the donkey. Harlequin is taking off his hat and greeting the characters on the left. The subject derives from the comedy of the same title by Fatouville.

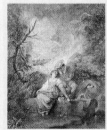

◆ NEST HUNTER (1710)

The picture centers on the couple seated on a grassy hill. The naturalistic scene emphasizes the idyllic atmosphere, reinforced by the flowers next to the young woman and the light, very bright colors. The female figure was inspired by the new mother in *The Birth of Louis XIII*, one of the paintings in Rubens' series of paintings dedicated to Maria de' Medici.

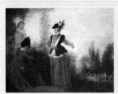

◆ ADVENTURESS (1712?)

This work is the *pendant* of the *Enchanter*. The two titles refer to a book containing the entire *corpus* of Watteau's engravings, called the *Recueil Jullienne*, after the collector who had it realized in 1727. Against the background of a garden are two figures; the *silhouette* of one of the young women stands out, her energy evidenced by her erect pose, her bent arm with hand on hip, and her decisive look.

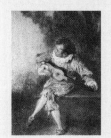

◆ GUITAR PLAYER (MEZZETTINO) (1715)

The figure of the guitar player appears often in Watteau's works, easily fitting in with the gallant subjects typical of his paintings. This painting is characterized by soft light with luminous touches, particularly intense in the figure of Mezzettino. The picture became well known through engravings.

◆ PERSPECTIVE (1715)

The picture reproduces the park of the Castle of Montmorency, property of Pierre Crozat from 1709. It is the only picutre where Watteau reproduced a certainly identifiable place, although he adapted the position of the trees to make it seem like a stage. The theatrical character of the picture is confirmed by the positions and poses of the various personages.

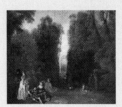

◆ NYMPH SURPRISED BY A FAUN (JUPITER AND ANTIOPE) (1715)

Watteau's predilection for the northern art of Rubens and Van Dyck and the sixteenth century Venetian painters, in particular Titian and Veronese, is fully evident in this painting. The first title of the picture, *Jupiter and Antiope*, was not chosen by the painter, and the other title was preferred because the painting does not show any of the attributes of Jupiter.

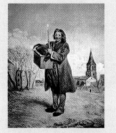

◆ STROLLING MUSICIAN WITH GROUND-HOG (1716)

The musician is related to a series of subjects that described various trades or peoples of the era. He was also referred to as *Savoiard*, a generic term meaning wandering tradesman. *Pendant* to the galant figures in Watteau's painting, the wanderers became a *topos* of post-Symbolist poetry which reached its height in the works of Laforgue.

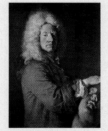

◆ ANTOINE PATER (1716?)

Critics do not all agree on attributing to Watteau this bright portrait of the sculptor, the father of Watteau's pupil Jean-Baptiste. The way the light defines the volumes clearly, incisively evidencing the physiognomy, is in fact very different from Watteau's usual misty, irregular style. However, his use of a more vigorous manner in the portrait of the musician *J.-F. Rebel* tends to confirm the attribution.

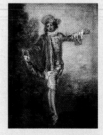

◆ INDIFFERENT (1717)

Renoir was very fond of this picture, together with its *pendant, Young Woman with Lute (La Finette)*. The young man seems to be portrayed in the moment just before the beginning of the dance. His pose and gestures suggest an idea of hesitation, accentuated theatrically. Although damaged by past restorations, the painting still shows precious light effects on the young man's suit.

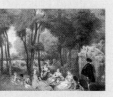

◆ CHAMPS-ELYSEES (1717?)

Watteau commonly repeated compositional schemes, as shown by comparison of the group of figures on the right in this painting and in *Country Amusements* (1718). In addition, the statue of the sleeping female has been taken from the *Nymph Surprised by a Faun*. Also, in this picture the green of the woods is enlivened by the golden light which contributes to the gracefulness of the scene.

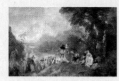

◆ THE EMBARKMENT FOR CYTHERA (1717)

The scene develops like a dance in which couples move in procession toward the boat that goes to the island of love. The lightness of touch and misty atmosphere give the picture a sense of both harmony and indefiniteness. The structure of the composition was taken up again by Watteau in the Berlin painting.

◆ FOUR MASKED FIGURES (MASQUERADE) (1717?)

Watteau cultivated his whole life long a profound interest in the world of theater and spectacle, directly witnessed in his paintings. Originally this picture was part of the Crozat collection; in 1772 it was acquired by Catherine II. The half length representation of the figures recalls Venetian Renaissance figurative tradition.

◆ BLUNDER (1717)

This apparently "gallant" scene shows Watteau's subtle sensitivity in representing the complex range of amorous feelings. The picture shows a couple seated on the grass. The young man is captured as he dares to steal an embrace. The woman's reaction, seen from behind, is expressed by her gesture of pushing him away with her hand and the nervous movement of her back, revealed by the tautness of her dress.

◆ A LADY AT HER TOILET (1717?)

In addition to *scenes of gallantry*, Watteau's work is fascinating also for some more or less vaguely erotic subjects. In this painting the figure of the woman undressing has been based on Rubens and in turn it became a model for the vast production of erotic paintings in the eighteenth century. Another famous painting on this subject is Jean-Honoré Fragonard's *Without Nightgown*.

◆ OUTDOOR GATHERING WITH FOUNTAIN, MASK-CHARACTERS AND PIPE PLAYERS (VENETIAN PARTIES) (1717)

The title *Venetian Parties* is due to the figure dressed as Pantaloon. The picture belonged to Jullienne, Watteau's collector friend. The artist's *pentimenti*, confirmed by the preparatory drawings, include the figure of Pantaloon, slimmer and younger in the first draft, and the dancer's dress, which was longer.

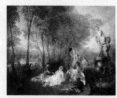

◆ YOUNG COUPLES WITH A STATUE OF VENUS AND CUPID (LOVE–FEST) (1717)

The statue of Venus and Cupid in this picture returns in *The Embarkment for Cythera* now in Berlin, showing the artist's habit of using the same iconographic solutions in different paintings. Typical of Watteau's painting is the lighting of the groups of people immersed in nature; it seems practically to radiate from the figures themselves.

◆ THE EMBARKMENT FOR CYTHERA (1718-19)

This version of the painting, now in Berlin, has been enriched by additional elements compared to the Louvre version. There are more couples in the procession, and the sinuous wave of lovers fills up the picture. Notice also the mast of the boat, with cupids climbing up it and flying around in a circle to raise the sails.

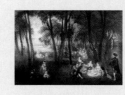

◆ COUNTRY AMUSEMENTS (1718)

Watteau's fame was linked to his representation of love and the amusements of the aristocratic society of his times. The scene here presents a description of games, conversations, courtships developed into a fluent narrative. The light that radiates from behind the figures seems to isolate them, while a touch of gold color revives the tufts of grass and the leafy branches of the trees.

◆ ENCHANTMENTS OF LIFE (1718)

The picture develops as if on a stage flanked by high two colored columns and with the backdrop of a landscape fading in the distance. Center stage is occupied by a lute player, accompanied by a lady playing the guitar in the group of figures on the left. On the right a black servant takes a bottle from a copper bucket.

◆ ACTORS OF THE *COMÉDIE ITALIENNE* (1718)

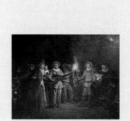

The painting was done as one of a pair with *Actors of the Comédie-Française*. It is the only nocturnal scene done by Watteau, who represents here certain aspects of the Italian theater banned from Paris by Louis XIV. Both torches and lanterns were commonly used in the "excellent nocturnals" done by the Italian comedians, and together with the moon they are used here to give the picture light.

◆ ACTORS OF THE *COMÉDIE-FRANÇAISE* (1718)

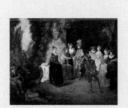

The scene develops in a circle, with the center empty, as if on a stage awaiting the entrance of the actors: the man in red on the right and the lady in blue on the left. In the background some people raise their glasses in a toast, others are waiting to go into action. Nature and architecture together form the backdrop for the scene.

◆ GILLES AND FOUR OTHER MASK-CHARACTERS OF THE *COMMEDIA DELL'ARTE* (1717-19?)

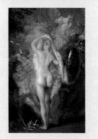

The strange, disquieting sensation of this painting derives from the isolated, monumental presentation – viewed from below – of the figure of Gilles, who has a melancholy expression and awkward stance. His white costume stands out against the sky: this isolation recalls the later painting of Manet.

◆ THE JUDGMENT OF PARIS (1720)

Watteau's works on mythological subjects reveal his interest in nude studies. The choice of theme and the long and sinuous forms of the bodies show the influence of Venetian painting as well as of the sixteenth century School of Fontainebleau, in particular that of Primaticcio (1504-1570). In this painting the brushwork is sketchy and light infuses the entire surface.

◆ GERSAINT'S SIGN (1720)

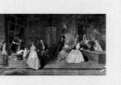

Upon his arrival in Paris in 1720 after a stay in England, Watteau offered to do a sign for the painting shop of his friend Gersaint, to "flex his fingers". Now in Berlin, this painting was in fact originally scalloped on the top and of the same dimensions as the arch over the shop entrance. The picture is considered one of Watteau's masterpieces, a sort of dialogue between word and painting.

TO KNOW MORE

These pages present some documents useful for understanding different aspects of Watteau's life and work, the basic stages in his biography, technical details and the location of the principal works presented in this volume, and an essential bibliography

DOCUMENTS AND TESTIMONIES

The small and the pleasant

Critics of the times did not pay much attention to Watteau's work, which was appreciated above all by the small group of art experts and patrons whom he knew, including Gersaint, Mariette and Sirois. After Watteau's death the criticism of Caylus and Voltaire emphasized that his painting failed to adhere to the pedagogic cultural propositions of the Enciclopédie.

"Watteau was successful in the small figures that he drew and grouped together well; but he never did anything on a grand style, because he wasn't capable."

[Voltaire, *Le Temple du goût*, 1731]

Watteau's scarse production in the historical genre was lamented also by other intellectuals, some of whom, however, emphasized his original qualities.

"It is true: his works are not first rate. However, they have a particular merit: there is nothing more pleasing in that genre [...] Wateau [sic], who had become melancholy because of his work, did not paint himself as such in his works, where there is a predominance of gaiety, a lively and penetrating spirit, a natural way of understanding, precision of design, true colors, all realized with a swift stroke and an exceptionally fine and light touch; there is nothing better than the character of his texts, where nature appears as it is; to so many delights he added excellent landscapes and backgrounds marvellous for his perspicacity of color: not only did he excel in gallant, country scenes, but also in military ones."

[A.-J. Dezailler D'Argenville, *Abrégé de la vie des plus fameaux peintres*, 1745-52]

Condemnation by Diderot and praise from Reynolds

Diderot's drastic judgment sides with that of Voltaire. In addition to depreciating Watteau's painting, considered modest in subject matter, he added the accusation of excessive weakness, the result of the intellectual encyclopedist's critical evaluation of the frivolous habits of the aristocracy.

"Talent imitates nature and taste regulates its choice: nonetheless I much prefer the coarse to the lightweight, and I would give ten Watteaus for a single Teniers."

[D. Diderot, *Pensées détachées sur la peinture*, c. 1775]

Diderot's criticism is contrasted by the impassioned praise of the aristocrat Reynolds.

"Watteau is a master whom I adore. In his figures he unites perfect design with the spiritual touch of Velazquez and the color of the Venetians."

[J. Reynolds, in W.T. Whitley, *Art in England 1821-27*, 1930]

Théophile Gautier expressed a serene judgment, capable of grasping the profundity of Watteau's art beyond its apparent lack of responsibility.

"Although he painted only scenes of gallantry and subjects inspired by the *Commedia dell'arte* Watteau was a great painter. He knew how to express a new aspect of painting and was able to see nature through a special prism [...]. He had grace, elegance, self-possession, and his work is serious, even though the genre he cultivated seems frivolous; it is a perpetual party [...]. Faced with such gay pictures, so spirited, light in tone, with blue backgrounds like Bruegel's paradises, one would be tempted to attribute the painter with unalterable good humor [...]. That would be a mistake. Watteau suffered poor health and was melancholic [...]."

[T. Gautier, *Guide de l'amateur au Musée du Louvre*, c. 1865]

Modern criticism

In the last century criticism provided new, more profound keys for reading and understanding Watteau's work.

"At the outset the Louvre *Embarkment* seems to belong to the 'light' genre of painting [...]. But Watteau's interest was not limited to the description, more or less faithful, of that gallant game; he had discovered and embodied the forces which unite a couple, which carry it in spirit towards far away chimeras and lost paradises [...]. But the *Embarkment* is also the image of a daydream, the nostalgia of a sick and solitary artist for the inaccessible paradise of happiness."

[Ch. de-Tolnay, *L'Embarquement pour Cythère de Watteau au Louvre*, in *Gazette des Beaux-Arts*, 1955]

The comments on Watteau as a painter of the theater are interesting as well.

"Few have known better how to create a world. If the theater attracted Watteau, it was above all for its dream-like quality. And this dream is transcended by Watteau himself, to recreate it even more intensely [...]. Now, Watteau achieves his poetics thanks to the intensity of his human sense, much more than for the prestige of technique; thus it was not transmittable."

[J. Thuillier-A. Châtelet, *La Peinture française de Le Nain à Fragonard*, 1964]

"Watteau is, without doubt, the French painter with the most acumen in presenting the essence of the stage. And he was the artist who best showed Italy as the mother of modern theater. But this notwithstanding, this painter, French or not, never went to Italy and the theatrical world he made known with his pencil and brush was not that of the Italian troupe in Paris."

[F. Moreau, *L'Italia di Antoine Watteau, ovvero il sogno dell'artista*, in *Quaderni di teatro*, VIII, n.29, 1985]

1684. Jean-Antoine Watteau born in Valenciennes, in the Hainaut region, now on the border between France and Belgium, which Louis XIV had conquered in 1677. At the time the history and culture of the city were firmly established in the Flemish orbit.

1702. Moved to Paris where he worked for a time with an unknown painter-dealer on the Nôtre-Dame Bridge, preparing figures for devotional pictures.

1703. Went to work with Claude Gillot, a painter specialized in theatrical costumes and sets, where he remained until 1707-08.

1709-1710. Classified second in the *Prix de Rome* but did not go to Rome, and never went to Italy. Continued his preparation under the guidance of Charles III Audran who transmitted to him an interest for the bright, whirlwind painting of Rubens, sustained in Paris mainly by the painter La Fosse.

1710-1715. These years are the poorest regarding information on Watteau's life. After this he was introduced to the collector Pierre Crozat. Through him Watteau was able to study the works of the Venetian painters, of Rubens, Van Dyck, Rembrandt, and Jordaens, who stimulated the anti-academic vein in his art.

1712. Watteau presented some paintings to the Académie Royale de Peinture of Paris, hoping to obtain a grant to study in Rome. But the academicians were struck by his qualities and decided to accept him into the Académie. As his painting of *réception*, he delivered *The Embarkment for Cythera* in 1717, after long elaboration and repeated, severe reprimands.

1715-1718. . He painted pictures showing the accord, typically Venetian, between figures and landscape: in particular the *Berlin Concert* (c. 1717) and *Country Amusements* (1718), an explicit homage to Giorgione's *Concert*.

1719. At the end of the year Watteau was in London where he remained until 1720. Although sick, he painted some pictures for the famous physician Richard Mead who was treating him.

1720. He returned to Paris where he was the guest of the art dealer Gersaint, for whose shop he painted *Gersaint's Sign*. He was introduced to the Italian painter Rosalba Carriera who was staying with Crozat.

1721. At the request of the collector, Carriera did Watteau's portrait. Then Crozat asked Watteau to do engravings of the paintings in the collections of the king, the regent and other collectors. In the spring Watteau went to live in Nogent-sur-Marne, where he died on July 18, not yet 37 years old.

Below is a catalogue of Watteau's principal works that can be seen in private collections and other places open to the public. The list of the works is in alphabetical order of the city in which they are located. The information presented is: title, date, medium and base, dimensions in centimeters.

ANGERS (FRANCE)
Country Gathering with Six Personages, 1715?; oil on canvas, 67x51; Musée des Beaux-Arts.

BERLIN (GERMANY)
Outdoor Wedding, 1710; oil on canvas, 65x92; Charlottenburg Castle.

Concert, 1717; oil on canvas, 66x91; Charlottenburg Castle.

Love at the French Theater (Actors of the Comédie Française), 1718; oil on canvas, 37x48; Staatliche Museen.

Love at the Italian Theater (Actors of the Comédie Italienne), 1718; oil on canvas, 37x48; Staatliche Museen.

The Embarkment for Cythera, 1718-19; oil on canvas, 130x192; Charlottenburg Castle.

Gersaint's Sign, 1720; oil on canvas, 163x306; Charlottenburg Castle.

BOSTON (UNITED STATES)
Perspective, 1715; oil on canvas, 46.9x56.7; Museum of Fine Arts.

CHANTILLY (FRANCE)
Guitar Player (Mezzettino), 1715; oil on canvas, 24x17; Musée Condé.

Venus Disarming Cupid, 1715; oil on panel, 38x47; Musée Condé.

Farmers' Gathering, 1716?; oil on canvas, 31x44; Musée Condé.

Girl with Roses, 1720?; oil on panel, 24x17; Musée Condé.

DRESDEN (GERMANY)
Young Couples with Statue of Venus and Cupid (Pleasures of Love), 1717; oil on canvas, 61x75; Gemäldegalerie.

Country Gathering with Statue of a Reclining Woman, 1717-18; oil on canvas, 60x75; Gemäldegalerie.

EDINBURGH (GREAT BRITAIN)
Nest Hunter, 1710; oil, 23.17x18.7; National Gallery of Scotland.

Outdoor Gathering with Fountain, Mask–Characters and Pipe Player (Venetian Parties), 1717; oil on canvas, 56x46; National Gallery of Scotland.

LONDON (GREAT BRITAIN)
Gallant Harlequin, 1716; oil, 34x26; Wallace Collection.

Mezzettino and Four Other Characters of the Commedia dell'arte (Mezzettino Family), 1717?; oil on panel, 26x20; Wallace Collection.

The Pleasures of Dance, 1717; oil on canvas, 52.7x65.7; Dulwich College.

A Lady at her Toilet, 1717; oil on canvas, 37x44; Wallace Collection.

Country Amusements (Country Gathering with Statue of a Seated Woman), 1718; oil on canvas, 88x125; Wallace Collection.

Hunt Meeting, 1720; oil on canvas, 124x187; Wallace Collection.

MADRID (SPAIN)
Marriage Contract in the Country, oil on canvas, 48x55; Prado.

Gathering Near a Fountain with Statue of Neptune (Saint-Cloud Gardens), oil on canvas, 48x56; Prado.

MOSCOW (RUSSIA)
Soldiers' Camp (Temporary Camp), 1710; oil on canvas, 32x45, Pushkin Museum.

NANTES (FRANCE)
Harlequin Emperor of the Moon (Harlequin in a Cart and Three Other Characters of the Commedia dell'arte), 1708?; oil on canvas, 65.3x82; Musée des Beaux-Arts.

NEW YORK (UNITED STATES)
Mezzettino with guitar, 1717-19; oil on canvas, 55.2x43.1; Metropolitan Museum.

French Actors, 1720; oil on canvas, 57x73; Metropolitan Museum.

ORLÉANS (FRANCE)
Monkey Sculptor, 1710?; oil on canvas, 22x21; Musée des Beaux-Arts.

PARIS (FRANCE)
Autumn, 1715; oil on canvas, 48x40.5; Louvre.

Nymph Surprised by a Faun (Jupiter and Antiope), 1715; oil on canvas, 72x110; Louvre.

Finette (Young Woman with Lute), 1717; oil on canvas, 19x25; Louvre.

The Embarkment for Cythera (Pilgrimage to the Island of Cythera), 1717; oil on canvas, 128x193; Louvre.

Indifference, 1717; oil on canvas, 19x26; Louvre.

Blunder, 1717; oil on canvas, 50x41; Louvre.

Gathering in a Park with Flute-player, 1717; oil on canvas, 32x46; Louvre.

The Judgment of Paris, 1720; oil on canvas, 41x37; Louvre.

ST. PETERSBURG (RUSSIA)
Soldiers' Camp (Temporary Camp) [Pauses in War], 1714; oil on metal, 21x33; Hermitage.

Soldiers Marching, 1714; oil on metal, 21.5x33.2; Hermitage.

Masquerade (Four masked figures), 1717?; oil on panel, 19.8x24.8; Hermitage.

STRASBOURG (FRANCE)
Cook (Scullery-maid), c. 1703; oil on canvas, 53x44; Musée des Beaux-Arts.

TROYES (FRANCE)
Adventuress, 1712?; oil on copper, 18.9x23.7; Musée des Beaux-Arts.

Enchanter, 1712?; oil on copper, 18.5x25.5; Musée des Beaux-Arts.

VALENCIENNES (FRANCE)
Antoine Pater, 1716?; oil on canvas, 78x58; Musée des Beaux-Arts.

BIBLIOGRAPHY

For further knowledge of the various periods of his artistic development, it is advisable to consult general catalogues of Watteau's work.

1736 J. de Jullienne, *Abregé de la vie d'Antoine Watteau,* Paris.

1744 E.-F. Gersaint, *Notes sur Watteau,* in *Catalogue raisonné des diverses curiosités du cabinet de feu M. Quintin de Lorangère,* Paris.

1856 A.-C.-P. Caylus, *La vie d'Antoine Watteau, lue à l'Académie Royale, le 3 Février 1748,* Paris.

1866 L. Dumont, *A. Watteau,* Valenciennes.

1867 L. Cellier, *A. Watteau. Son enfance, ses contemporaines,* Valenciennes.

1875 E. De Goncourt, *Catalogue de l'œuvre peint, dessiné et gravé d'Antoine Watteau,* Valenciennes.

1921 P. Champion, *Notes critiques sur les vies anciennes d'Antoine Watteau,* Paris.

1922 E. Hildebrandt, *Antoine Watteau,* Berlin.

1924 E. Pilon, *Watteau et son école,* Paris.

1928 L. Réau, *Watteau,* in L. Dimier, *Les peintres français du XVIII^e siècle,* Paris.

1943 A.E. Brinckmann, *Jean-Antoine Watteau,* Vienna.

1947 H. Adhémar, *L'imbarquement pour l'île de Cythère - Watteau. Le musée des chefs-d'œuvre,* Paris.

1950 H. Adhémar, *Watteau, sa vie, son œuvre,* Paris.

1955 Ch. de Tolnay, *L'Embarquement pour Cythère de Watteau au Louvre,* in *Gazette des Beaux-Arts,* n. 46.

1957-58 K.T. Parker, *Antoine Watteau. Catalogue complet de son œuvre,* Paris.

1959 M. Gautier, *Watteau,* Paris.

1968 G. Macchia, E.C. Montagni, *L'opera completa di Watteau,* Milan.

1972 *Jean-Antoine Watteau,* edited by J. Ferré, Madrid.

1982 *Jean-Antoine Watteau. Einschiffung nach Cythera. L'Ile de Cythera,* exh. cat., Frankfurt.

1984 R. Neumann, *Watteau's L'Enseigne de Gersaint and Baroque Emblematic Tradition,* in *Gazette des Beaux-Arts,* n. 104.

Watteau 1684-1721, exh. cat., Washington-Paris-Berlin.

M. Roland-Michel, *Watteau 1684-1721,* Munich.

D. Posner, *Antoine Watteau,* Berlin.

1985 F. Moureau, *L'Italia di Antoine Watteau, ovvero il sogno dell'artista,* in *Quaderni di teatro,* VIII, n. 29.

1987 *Antoine Watteau (1684-1721) le peintre, son temps et sa légende,* edited by F. Moureau and M. Morgan Grasselli, Paris-Geneva.

1992 M. Vidal, *Watteau's Painted Conversations. Art, Literature and Talk in Seventeenth- and Eighteenth-century France,* New Haven-London.

1994 S. Cohen, *Un Bal Continuel: Watteau's Cythera Paintings and Aristocratic Dancing in the 1710s,* in *Art History,* n. 17.

1995 M. Eidelberg, *Watteau's Italian Reveries,* in *Gazette des Beaux-Arts,* n. 6.

ONE HUNDRED PAINTINGS:

every one a masterpiece

—— Also available: ——

*Raphael, Dali, Manet, Rubens,
Leonardo, Rembrandt, Van Gogh,
Kandinsky, Renoir, Chagall*

Vermeer
The Astronomer

Titian
Sacred and Profane Love

Klimt
Judith I

Matisse
La Danse

Munch
The Scream

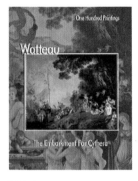

Watteau
The Embarkment for Cythera

Botticelli
Allegory of Spring

Cézanne
Mont Sainte Victoire

Pontormo
The Deposition

Toulouse-Lautrec
At the Moulin Rouge

—— Coming next in the series: ——

*Magritte, Modigliani, Schiele,
Poussin, Fussli, Bocklin, Degas,
Bosch, Arcimboldi, Redon*